The Art of
Encaustic Painting

Contemporary Expression in the
Ancient Medium of Pigmented Wax

Joanne Mattera

WATSON-GUPTILL PUBLICATIONS/NEW YORK

For My Family

Text copyright © 2001 by Joanne Mattera
Foreword copyright © 2001 by Jerry Cullum
Artwork © 2001 by the individual artists unless otherwise noted

First published in 2001 by
Watson-Guptill Publications
a division of VNU Business Media, Inc.
770 Broadway, New York, NY 10003
www.wgpub.com

Senior Editor: Candace Raney
Editor: Gabrielle Pecarsky
Designer: Areta Buk
Production Manager: Ellen Greene

Library of Congress Cataloging-in-Publication Data

Mattera, Joanne
 The art of encaustic painting : contemporary expression in the ancient medium of
pigmented wax / Joanne Mattera.
 p. cm.
 Includes bibliographical references and index.
 ISBN 0-8230-0283-7
 1. Encaustic painting--Technique. I. Title.

ND2480 .M38 2001
751.4'6—dc21

2001017934

Printed in China

First printing, 2001

3 4 5 6 7 8 9/08 07 06 05 04

Disclaimer: The author and publisher have made every effort to insure that all the instructions
given in this book are accurate and safe, but they cannot accept liability, whether direct or
consequential and however arising. If you are pregnant or have any known or suspected allergies,
you may want to consult a doctor about possible adverse reactions before performing any
procedures outlined in this book. The techniques and materials in this book are not for children.

Contents

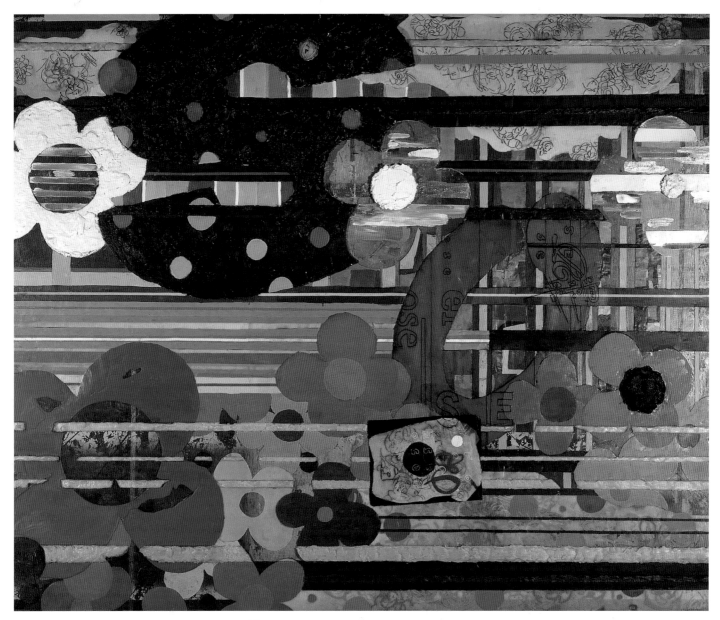

Sabina Ott **LOVING REPEATING IS ONE WAY OF BEING**
oil, encaustic, and enamel on panel, 60 in. × 72 in., 1999

Foreword:
Concealment and Revelation

I remain astonished by the sheer versatility of artists' use of the encaustic medium, from something as simple as cigarette burns in a sheet of wax-coated paper at one extreme to the intricate solidities of Miriam Karp's bas-relief knots and meanders at the other. In between, the many uses of transparency and translucent density continue to surprise and delight—a dynamic of concealment and revelation ranging from actually embedded objects through the purposeful obscuring of precise lines to the equally precise revelation of hidden layers, via everything from geometrically exact incisions to thoughtfully arranged abrasions.

Similar strategies recur in artists from across the country without becoming stylistically repetitive. The medium's properties lend themselves to a lush romanticism of landscape, as one can see in certain works by Amanda Crandall (only one of many widely varying artists), but any thoughts of a neo-Romantic rebirth of encaustic are at once rebutted by the more formal uses to which Robert Ryman and, indeed, Joanne Mattera, have put the material. Melissa Meyer's calligraphic gestures illustrate the sort of restrained gorgeousness that might well be read as a blending of romantic/visionary and rational strains, though sensuous qualities shouldn't be simplistically equated with the emotional end of the spectrum.

A good many artists remain enraptured by the knowledge of historical precedent in the Fayum portraits, though, curiously, relatively few have attempted contemporary portraiture. The most notable exception, Tony Scherman, works mostly at the opposite extreme from the Fayums' intimacy, making even more close-cropped but utterly monumental images of famous faces. For many others, however, the medium is effectively ahistorical, with its suggestions of flesh making it a natural accompaniment to mixed-media sculpture about the body, for example, or its durability combined with color effects becoming just one more vehicle for experimentation, yielding work that's a simple extension of earlier pieces executed as, say, oil on canvas.

Miriam Karp **AFTER AUDEN**
encaustic on braced lauan, 48 in. × 36 in., 1997

Jasper Johns, of course, was a relatively early contemporary practitioner who used encaustic to lend depth and lusciousness to targets and flags that were, as is well known, meant to be insistently flat. Today, when flatness is no longer a fetish, Sabina Ott combines the outrageous palette of the new abstraction with downright excessive dimensional effects that are, once again, facilitated by the medium. On the other hand, such painters as Heather Hutchison are luminously beyond issues of dimensionality, while Peter Flaccus belongs to the school of abstraction that cites dimensionality in his imagery only to refuse it.

So it's difficult to summarize what's being done with encaustic today by painters and sculptors. It's considerably more meaningful to observe that the fascination with its possibilities continues to grow, and that art audiences have responded passionately to the variety of formal and emotional tonalities that the encaustic revival has made possible. Hence the usefulness of a book like the present one, which adds to the store of information through which intuitive response can be turned into well-informed looking.

—Jerry Cullum
Dr. Jerry Cullum is the senior editor of Art Papers Magazine.

ABOVE: Melissa Meyer **WHITE STREET (C18)**
encaustic on paper, 22 $^1/_2$ in. × 30 in., 1997

OPPOSITE TOP: Peter Flaccus **GRAY STUDY**
encaustic on plywood, 24 in. × 18 $^1/_2$ in., 1998

OPPOSITE BOTTOM: Joanne Mattera **INCONTRO I**
encaustic on canvas on braced lauan, 12 in. × 24 in., 1995
Collection of Anthony and Denise Mattera

Introduction:
The Apian Way

When I interviewed Jasper Johns for *Women's Wear Daily* in 1986, he remarked rightly of encaustic, "It's an archaic medium, and few people use it." Throughout the 1950s and 1960s he was virtually its sole practitioner, and at the time we spoke, just a handful of artists had gone beyond experimenting to create a serious body of encaustic work. Yet now, a decade and a half later, thousands of artists—impelled by the zeitgeist, the luminosity, or perhaps simply by the recent availability of good tools and materials—are exploring the possibilities of expression in pigmented wax. What a sweet irony it is that at the beginning of a new millennium, when cyber images are generated at the speed of light as pixels on a screen, a laborious medium that flourished over two thousand years ago should once again become a hot commodity.

And *hot* is the appropriate word here, for encaustic, from the ancient Greek *enkaustikos*, means "to heat" or "to burn." Heat is used at every stage of encaustic painting. The medium consists of beeswax melted with a small amount of resin to impart hardness; it becomes paint when pigment is added to the molten wax. Painting requires the artist to work quickly, for the wax begins to harden the moment it leaves its heat source. What makes encaustic unique—indeed, what makes encaustic *encaustic*—is the application of heat between layers of brushstrokes. Heat binds each layer to the one set down before it, so while the image may consist of discrete compositional elements, structurally the entire surface is one carefully crafted mass, a whole ball of wax, if you will.

THE BUZZ

The artwork and technical concerns you will encounter in this book span a vast range of images and aesthetics, but in this section, I have focused on art in which the apian elements—insects, honey, and the hive—are referenced, either in semblance or by suggestion. It seems a fitting introduction to a fragrant, sensuous, infinitely malleable medium that is produced, almost alchemically, from flower nectar via the tiny body of a bee.

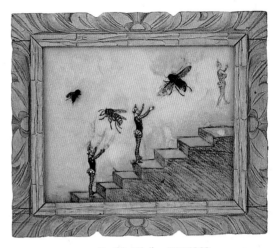

ABOVE: **Cynthia Winika BEE TOSS**
encaustic and mixed media on lauan panel,
10 7/8 in. × 12 3/4 in., 1998
Collection of George Minervini

OPPOSITE: **Martin Kline HIVED**
encaustic on linen, 7 in. × 7 in. × 4 in., 1999

ABOVE: Benjamin Long **FIRE AND HONEY**
encaustic and mixed media on panel, 32 in. × 21¼ in., 1998
Collection of McDonald's Corporation

RIGHT: Sara Mast **SWARM**
encaustic and mixed media on plywood, 32 in. × 48 in., 1997
Collection of 3M Company

Wax holds an elemental fascination for Heather Hutchison, who paints it onto a Plexiglas ground. "I love the smell of it, the way it goes on, the way it holds pigment and diffuses light." Her luminous *For the Bees* (opposite, left) would appear to be a minimalist totem to the material and its makers.

Some artists use wax direct from the apiary. Mari Marks Fleming's *Reliquary XV* (opposite, right) is made not only with beeswax but with hive separators. The connection between material and artmaking is as straight as, well, a bee-line: "Garnering what is precious, storing it away, distilling it into what is of greatest value," says the artist. For Sara Mast, smell and image are linked. In *Swarm* (below), Mast uses fragrant, unrefined beeswax as her medium. "The olfactory nature of the wax establishes an aroma that carries into the painting the presence of the bees and their work."

Cynthia Winika plays with bees. In her collage *Bee Toss* (page 9), diminutive harlequins get an entomological workout as they pitch monster bees up a staircase. Scale is set by the inclusion of actual insects. (No bees were killed in the making of this piece; Winika, who is allergic to stings, used only insects she found dead in her studio.)

Martin Kline's *Hived* (page 8) is as much sculpture as painting. Taking his cue from nature, he cultivates each work, building it up organically into a swarm of winglike forms. Unlike the cooperative activity of the hive, however, he is a single artist working alone in the studio, "repeating the brushstroke over and over."

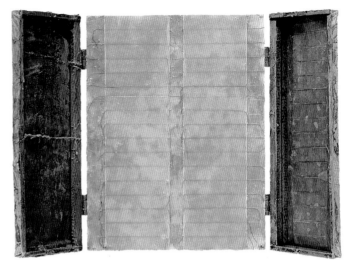

Mari Marks Fleming **RELIQUARY XV**
beeswax and mixed media on braced Masonite,
18 in. × 27 in. × 2 in., 1995

Heather Hutchison **FOR THE BEES**
beeswax and pigment on Plexiglas,
121 in. × 59³/₄ in. × 3¹/₂ in., 1992

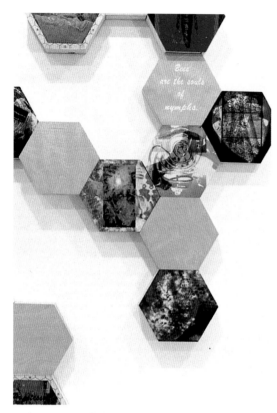

Nancy Macko **HONEYCOMB WALL,** detail
mixed media with beeswax, 1993–1994

In *Fire and Honey* (page 10), Benjamin Long refers not to process but to heat. A hexagonal pattern acknowledges the sweet liquid, while a flaming symbol (perhaps alchemical?) in metallic encaustic notes the necessity of melting the wax to workability.

With her feminist mixed-media installation, *Dance of the Melissae* (opposite), Nancy Macko explores honeybee society and its relationship to art, science, technology, and ancient matriarchal cultures. *Aphrodite's Lattice,* the floor piece in wax and lead, honors the Pythagorean concept of the hexagon as the essence of cosmic symmetry.

CROSS-POLLINATION

The subtext of this introduction might well be "The Birds and the Bees," for more than one artist has stated plainly, "I'm in love with the wax." Or as Stephanie Brody Lederman puts it, "I was seduced." Indeed, much of the language used to describe the medium is the vocabulary of erotica: "luscious," "fleshy," "revealing." Mia Westerlund Roosen calls wax "blatantly sensuous." To Bill Zima, wax's tactility is "utterly romantic." There is even the tango of "twoness": "The constant flux of heating and solidifying starts a dancelike interaction between me and the medium," says Olivia Koopalethes.

Then there is archaeology, for wax allows us to quarry a history of our own making—to scrape down and dig back to elements from another time, even if that time was just moments ago or a few layers beneath a translucent surface. This is my terrain. Wax allows me to do easily what I had done messily and with great effort in acrylic and oil. But I am not alone: Much of the work represented in this book is rich with surfaces excavated to reveal secrets or seeded tantalizingly with objects of personal meaning.

BEYOND THE CULT OF WAX

While wax is undeniably unique to the senses, it is not an object in and of itself; it is a means of presenting aesthetic interests, a medium. I see this in my own work, where the grid has been my underlying focus, whether in oil on canvas, graphite on paper, or encaustic on panel. You may have found this yourself. Peter Flaccus did.

"When I first began using encaustic, the results seemed entirely new to me," Flaccus says. "However, as time goes on, I see that my abstraction has not changed in its painterliness and materiality, its calligraphic gesture, or its color and light. Therefore I regard my use of encaustic not as giving me membership in the cult of a special art medium, but rather giving me a new approach to my longtime painting concerns."

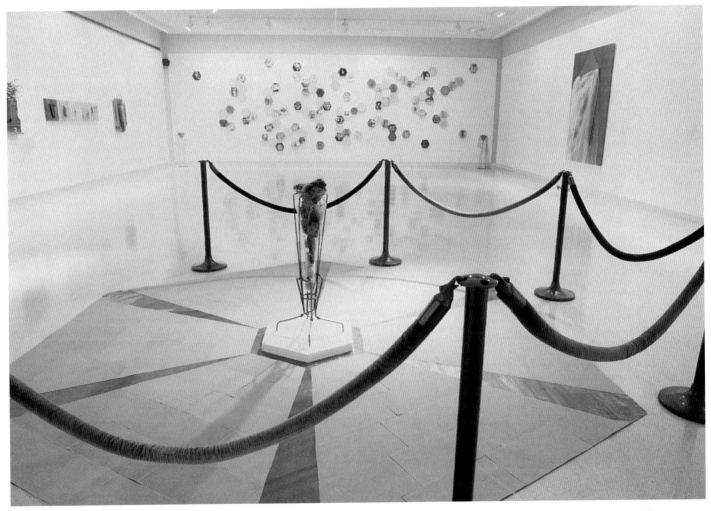

Nancy Macko
DANCE OF THE MELISSAE
mixed media with beeswax, 1994

This installation, a multimedia, multisensory work evocative of a matriarchal temple, explores honeybee society and its relationship to art, science, technology, and ancient goddess cultures. (Melissae is Greek for bees.)

APHRODITE'S LATTICE, foreground
beeswax and lead sheeting, 144 in. × 144 in.

The Pythagoreans perceived the hexagon as an expression of the spirit of Aphrodite, whose sacred number was six. They worshipped bees as her sacred creatures that understood how to create perfect hexagons in their honeycomb.

HONEYCOMB WALL, background
beeswax and mixed media on panel, each 11$\frac{1}{2}$ in. × 11$\frac{1}{2}$ in.

Nature, technology, mythology, and geometry come together in elements ranging from a diagram of honey's glucose molecule to hive images to goddess-centered spirituality.

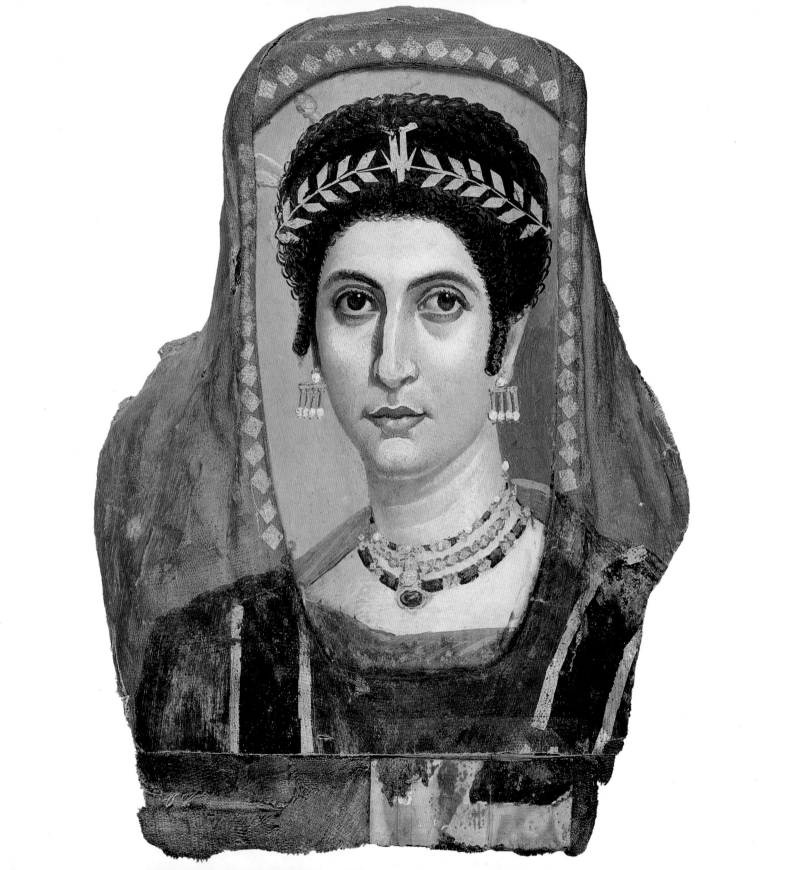

A Brief History of Encaustic

Encaustic in the Ancient World

The history of encaustic has arrived on our contemporary shores in evocative fragments—an archival scrap of information here, a startling image there—borne, not unlike a message in a bottle, by vessels from various times and places.

PAINTED SHIPS

We begin in ancient Greece, where shipbuilders used beeswax to caulk the joints and waterproof the hulls of their vessels. It would seem a short creative leap to pigmenting the wax and then patterning the surface of a waxed hull. Homer, writing in 800 B.C., makes note of painted warships sailing into Troy. We can only speculate on the designs on these vessels and the empowering effect that they would have had on the soldiers within—or the terror that blood red markings, say, might have struck in the enemy.

However they were painted, the curved hulls of seagoing barques led Greek artists to take encaustic in two directions: flat for easel painting and fully dimensional for the polychroming of clay and marble sculptures. Pliny the Elder, the Roman historian writing in the first century A.D., mentions Apelles, Praxiteles, Pausias, and other artists from the fifth and fourth centuries B.C. as practitioners of encaustic. Beyond this notation, a visual record—a message *on* a bottle—remains. A krater from the fourth century B.C., now in the Metropolitan Museum of Art, depicts a sculptor applying wax to a marble figure.

Isidora, Considered

Supremely composed does not begin to describe this woman of a certain age, so beautifully coiffed and bejeweled. Not only is the wax surface in superb condition—its luminosity heightened by a modeling of the features with dramatic light and shadow—a portion of the *cartonnage*, the linen and plaster mummy case, is still attached to the panel. If the painted linen of other such mummies is an indication (not all were wrapped with white linen bandages), Isidora's brilliant orange shroud, perhaps embellished with hieroglyphics or other markings, would have cloaked the entire case. The existing fragment, with its gold-painted diamonds, certainly suggests that possibility. The portrait gets its name from an inscription on the cartonnage.

OPPOSITE: **Attributed to the Isidora Master**
PORTRAIT OF A WOMAN, ISIDORA
encaustic and gilt on wooden panel with a portion of cartonnage attached, 21⅝ in. × 13¾ in.,
circa A.D. 100–125
Collection of the J. Paul Getty Museum, Malibu, California
Photograph courtesy of the J. Paul Getty Museum

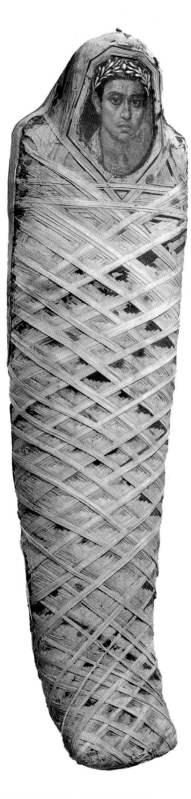

THE FAYUM PORTRAITS

In Greco-Roman Egypt, from 100 B.C. to A.D. 200, vessels of an entirely different sort bore encaustic paintings. Head-and-shoulder wax portraits were set into mummy casings designed to transport bodies of the deceased to a spiritual afterlife. These realistic, life-size pictures—painted, it is believed, during the person's lifetime—were a departure from the ritualized imagery created during thousands of years of Pharaonic rule. They were the culmination of a multicultural effort reflecting the diverse fabric of Nile Delta life.

A large Greek population had established itself in Egypt following Alexander's conquest in 330 B.C. With time and intermarriage, this group adopted some indigenous customs, such as embalming and wrapping the dead, while retaining and developing its unique talents, such as encaustic painting. When the Roman Empire claimed Egypt in 30 B.C., after the death of Cleopatra, it insinuated its own cultural trappings. Thus, encaustic funerary portraits evolved so that they were painted in wax in the Greek style—a full or three-quarter view illuminated with a light source that cast realistic shadows on the face—showing contemporary fashions and hairstyles of the Roman court, set into mummies wrapped in the Egyptian manner, and laid to rest in mortuary temples at Hawara, Antinoopolis, er-Rubayat, and elsewhere on high ground above the Fayum oasis.

The vast Fayum, a wellspring of life in the Egyptian desert, has lent its name to the encaustic portraits found there and throughout Egypt. We may assume that not all wax paintings were destined for the grave, but it is these portraits—over six hundred, painted on veneer-thin wooden panels—that have survived the passage of time. What draws you to them is their individuality; these are not generic representations, but idiosyncratic faces of people you might know. (Some scholars suggest that families in this society kept a mummy with them for months or years, comforted in their loss by the portrait's likeness.) If familiarity pulls you in, it is the resonant color and the virtuosic brushwork, a combination of light handling and rich impasto, that holds your gaze. The wax was applied in thin, dark-to-light, translucent layers to create fleshlike skin tones, but it was also laid down thickly to suggest the luxurious fabrics and jewelry that signified the sitter's station in life.

Materials used by the Fayum painters would be familiar to us today: beeswax, pigment, resin, brushes; the *cestrum*, a graving tool; and the *cauterium*, essentially a palette knife that was heated for fusing. (Accustomed to electricity, we today would find the *rhabdium*, a charcoal brazier, clumsy and inconvenient for melting wax.) While most portraits were executed in true encaustic, others were painted with wax emulsion—the so-called Punic wax described by Pliny: beeswax boiled with sea water and potassium carbonate, then bleached by the sun. Still others were a combination of both mediums.

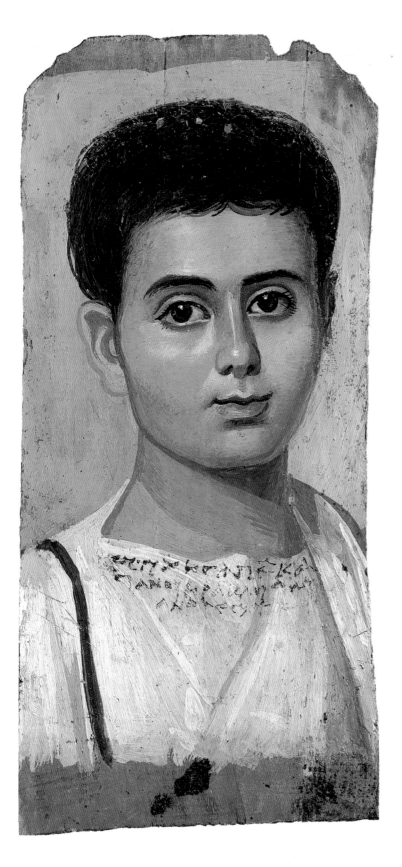

OPPOSITE: **MUMMY WITH INSERTED PANEL PORTRAIT OF A YOUTH**
encaustic on limewood (portrait)
and linen (mummy),
66 1/2 in. × 18 in. (shoulders) × 15 in.
(depth of foot case), *circa* A.D. 80–100
Collection of The Metropolitan Museum of Art,
Gift of the Egyptian Research Account and
the British School of Archaeology, 1911 (11.139)
Photograph © 1999, The Metropolitan
Museum of Art, New York

While the Greco-Roman custom of realistic portraiture was relatively new in the first century A.D., *a diamond-pattern wrapping of the mummy bandages had been established thousands of years earlier. This complete mummy, excavated in 1911 by W. M. Flinders-Petrie, provides a context for the Fayum portraits. Here you can see how the portrait panel is set into the casing so that the viewer looks onto the likeness of the deceased as if peering through a window—or, from another perspective, that the deceased, immortalized by the likeness, would have a means to look out onto eternity.*

LEFT: **PORTRAIT OF A BOY, EUTYCHES**
encaustic on limewood, 15 in. × 7 1/2 in.,
circa A.D. 50–100
Collection of The Metropolitan Museum of Art,
Gift of Edward S. Harkness, 1918 (18.9.2)
Photograph © 1998, The Metropolitan
Museum of Art, New York

Of all the encaustic portraits to come from Greco-Roman Egypt, perhaps this is the most touching, not only for the sitter's tender age and soulful expression, rendered so vividly in impastoed brushstrokes of olive-toned wax, but because he has a name and his brief life has a history. According to most sources, the inscription on the painted tunic reads, "Eutyches, freedman of Kasianos." A separate wooden label, widely believed to have accompanied Eutyches' mummy, indicates that this boy was a slave reared in the house of Kasianos and that he had been freed—only, from our point of view, to be delivered far too soon to the hands of another, more permanent, master.

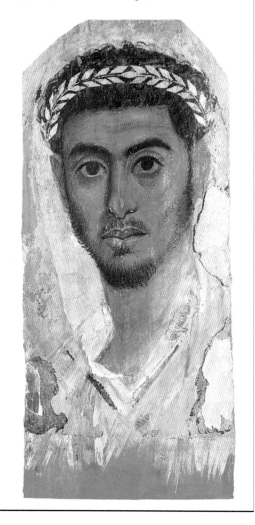

A SLIDE INTO OBSCURITY

The mummies' dark, dry, nearly airless tombs created a perfect archival environment. Though discoveries had taken place as early as the seventeenth century (and continue to be made today), the cache unearthed in 1888 by British archaeologist W. M. Flinders-Petrie from a large, Roman-era cemetery at Hawara is the most significant to date. It is surely ironic that while these wax paintings remained in almost perfect condition for two thousand years, the use of wax during that same period all but disintegrated. Even where it continued as a viable medium—in the glorious Byzantine icons, an extension of Greek portrait painting—it would fall out of favor by the seventh century.

Flinders-Petrie's discovery captured the imagination of some nineteenth-century painters, just as the excavations of Herculaneum and Pompeii in the eighteenth-century had sparked an "encaustic revival" in that period. But as artists throughout the centuries discovered new, less labor-intensive painting methods—tempera, fresco, oil painting, and, most recently, acrylic—encaustic became just a footnote in art history. It remained there until 1954, when a young painter, tired of waiting for his oils to dry, put encaustic to canvas.

LEFT: **PORTRAIT OF A MAN**
encaustic and gilding on wood panel, 17 1/4 in. × 7 3/4 in., *circa* A.D. 120–130
Photograph courtesy of the Brooklyn Museum of Art, Brooklyn, New York, Charles Edwin Wilbour Fund

Where it appears, gold is the topmost layer of color in the Fayum portraits. Pharaonic tradition equated gold with godliness and immortality, so gilding a portrait after the sitter's death acknowledged his or her transition from temporal earthly life to a more timeless spiritual existence.

OPPOSITE: **PORTRAIT OF A YOUNG WOMAN WITH A GOLD WREATH**
encaustic on limewood, 16 1/4 in. × 8 1/2 in., *circa* A.D. 90–120
Collection of The Metropolitan Museum of Art, Rogers Fund, 1909 (09.181.6)
Photograph © 1998, The Metropolitan Museum of Art, New York

Where the features of Isidora and Eutyches were carefully modeled, here the brushwork is looser and more expressionistic against a background that seems merely an afterthought. Perhaps this is simply a stylistic difference, as countless painters in different cities would have put wax to panel in their own ways over three centuries of Greco-Roman portraiture. Or perhaps it is one of timing, for while many portraits were painted during the life of the sitter and then cut down to be fitted into the mummy casing at the time of embalming, others were painted postmortem. That would seem to be the case here, where broad strokes stop abruptly on the panel, suggesting that only what would be visible was actually painted.

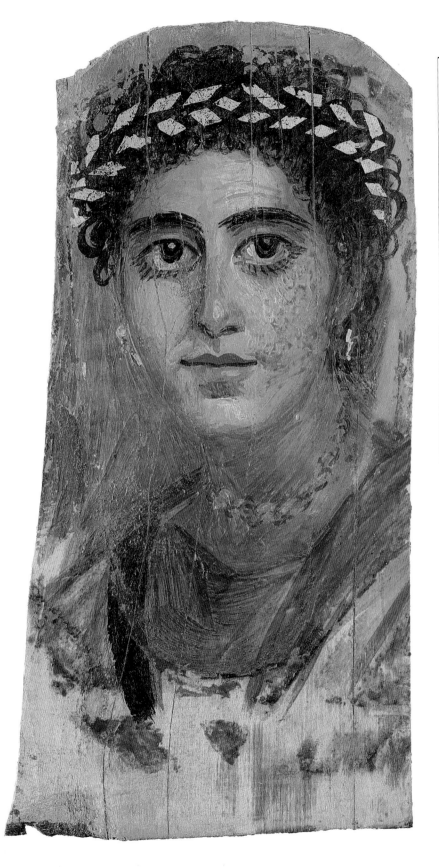

To the eye, the paint handling is light and direct. The layers of wax, as thin as gouache, were brushed directly onto a cypress panel one-sixteenth inch thick. The panel's curvature may have been intentional, to allow the portrait to be set directly above the deceased young man's own wrapped face, or it may have resulted from warpage after excavation. Scraps of the linen wrapping are visible, still attached with a resin adhesive.

Under magnification, there is a seemingly geologic upheaval. On a wood substrate expanding and contracting from shifts in heat and humidity, wax can start lifting off, says Tomkiewicz. At forty-times magnification, splits in the wood, extending toward the center from top and bottom, look like chasms; here, the wax has separated with the grain. Elsewhere, it has buckled into tiny villages of peaked roofs, called *tenting*.

The splits were stabilized from the back during an earlier treatment. To keep the tented wax from buckling further and flaking off, Tomkiewicz injected pure collagen adhesive (made from sturgeon bladder) into the tiny space beneath each tent. She then placed quarter-size sacks of lead shot wrapped in silk onto the areas she had just glued. These weights, heated on a coffee-mug warmer and separated from the painting by Japanese tissue, conform to the irregularities of the wax surface as well as the curvature of the panel, while the ever-so-gentle heat helps the glue accept the wax chips.

Normally, conservation is meant to be completely reversible. This classic fish glue is a good compromise, for, notes Tomkiewicz, "The problem with encaustic is that you can't use elevated heat or hydrocarbon solvents without altering the original, and not that much adheres to wax."

For storage and exhibition, the portrait is held in place on a shaped bed of silicone, covered with a Plexiglas housing, and kept at a steady 50 percent relative humidity and seventy degrees Fahrenheit. ●

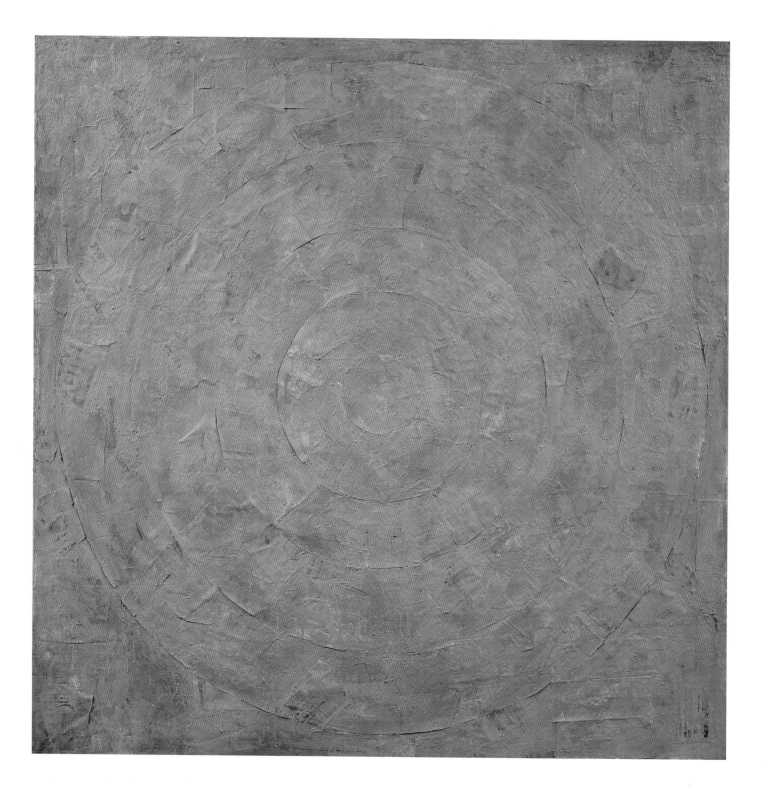

Contemporary Encaustic

The history of contemporary encaustic begins with its most famous practitioner, Jasper Johns. It was he, of course, who put pigmented beeswax on canvas in 1954. "I went out and bought some wax and started working. It was just right for me. Everything I did became clearer," he said in a 1984 *Vanity Fair* interview.

Those iconic early canvases, with their collaged targets, flags, numbers, and maps—"things the mind already knows," he has famously said—allowed him to focus on the act of painting. His surfaces were a spectrum of texture, slathered with brushstrokes and oozing with drips. As his imagery has evolved—the self-referential figure, crosshatch markings, and, recently, a string-and-wood appurtenance suspended like a bridge across a gray canvas—encaustic has remained essential to his oeuvre.

ENCAUSTIC BEFORE JASPER JOHNS

While Johns quite literally put encaustic on the map, a resurgence of wax as a medium had already been under way. In Mexico in the twenties, Diego Rivera used encaustic for easel painting and murals. In New York in the late thirties, Arthur Dove painted with wax emulsion. At the Boston Museum School in the forties, Karl Zerbe, who had trained as a chemist in his native Berlin, experimented with numerous formulas before settling on a wax/resin mix (eight parts beeswax, one part damar resin, one part Venice turpentine). His students included David Aronson, who went on to teach at Boston University, and Reed Kay, who wrote *The Painter's Companion, A Basic Guide to Studio Methods and Materials*.

Zerbe and Aronson were two of the artists featured in an earlier book, the now classic *Encaustic Materials and Methods* by Frances Pratt and Becca Fizel, published in 1949. This modest volume was a first, offering not only recipes and technical advice from practicing artists, but historical precedents. A contemporary reader might find the text overly concerned with esoteric ingredients—"montan wax," "copal gum," "oil of spike"—but for an artist at that time, and even for decades later, it was the foremost source of information about encaustic.

A Conversation with Jasper Johns

Over the past few years, encaustic materials have become increasingly available. Has this changed how you approach your work?

There has not been a change for me, because I formed my habits under earlier conditions and have stuck to the same procedures. I know that now there are catalogs of materials. I ordered some paint but haven't used it yet.

So you still make your own paint?

Yes.

How?

Beeswax, damar crystal, linseed oil. I used to add oil paint. At some point I stopped that in favor of the powder.

When I visited you some years ago, you were working with a saucepan on a hot plate. A recent photograph suggests you work the same way.

Yes, with some alterations. The original hot plate had an on-and-off switch, and now I have one with a rheostat. I can have it at any degree I want. The consequence is that I burn my encaustic much less.

Is it true you used to fuse with a hot plate on a stick?

Yes. It worked very well. The only problem is that it tended to be too hot. I worked with it for a very long time. ➤

OPPOSITE: Jasper Johns **GREEN TARGET**
encaustic on newspaper and cloth over canvas,
60 in. × 60 in., 1955
Collection of The Museum of Modern Art, New York;
Richard S. Zeisler Fund
© Jasper Johns/Licensed by VAGA, New York, New York
Photograph © 2001 The Museum of Modern Art, New York

RIGHT: Jasper Johns **WHITE FLAG**
encaustic and collage on canvas,
78 1/4 in. × 120 3/4 in., 1955
Collection of The Metropolitan Museum of Art, New York
© Jasper Johns/Licensed by VAGA, New York, New York
Photograph by Richard Carafelli

THE SIXTIES, SEVENTIES, AND EIGHTIES

In the years after Johns's acclaimed inaugural show at the Leo Castelli Gallery in 1958, encaustic began to surface, so to speak, among other painters. Working minimally in the late sixties into the seventies, both Brice Marden and Lynda Benglis produced bodies of work in wax. Marden's large-scale expanses, each a quiet presence with a soft, matte face, were not true encaustic—"oil remains the primary binder," he wrote in a technical statement—whereas Benglis's slim columns, also reductive in color and surface, were created with wax, resin, pigment, and heat as true encaustic.

Rachel Friedberg turned to encaustic in 1974, looking, she says, for "a mysterious surface onto which I could suspend thoughts." Aware of Johns's work but unfamiliar with the medium beyond the basics, she telephoned Frances Pratt when the latter's book proved hard to find. "She must have been well into her eighties at the time," says Friedberg. "I asked if she had a copy I could buy. She didn't. But she told me, 'Oh, dearie, just take a pencil and I'll tell you what to do.'" Thus provided with basic recipes directly from the author, Friedberg learned on her own by trial and error.

The late Nancy Graves, a sculptor who used wax in her constructions of camels and other animal figures, produced a series of mixed-media paintings with encaustic in the late seventies. At the same time, Michelle Stuart, who had been making installations and large-scale works imbued with earth she dug herself, added wax to the mix. More precisely, she says, "I added earth to the wax—unlike mud, wax doesn't dry and fall apart." Her earth/wax medium led the way to true encaustic. Working modularly on muslin-backed paper, Stuart applied

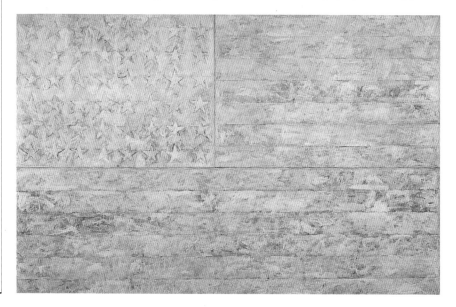

Jasper Johns FALL
encaustic on canvas, 75 in. × 50 in., 1986
Collection of the artist
© Jasper Johns/Licensed by VAGA, New York, New York
Photograph courtesy of Dorothy Zeidman

Do you paint with a palette knife?
Rarely. I apply the paint with a brush and flatten with the ironing tool. That's the smoothness you may notice.

Your paintings have logged a lot of travel time. Has transit or installation damage been a problem?
It has not been a great problem. I have noticed that certain paintings get damaged around the edges. Usually they're paintings that don't belong to me; I don't know how they've been treated over time. On occasion, for shows of my work, I have simply repaired the damage if no one objected. Earlier paintings cracked because of the collage element.

Are all your paintings framed?
Usually, they have a strip of wood around them to protect the edge.

Catalogs describe your work as "encaustic on canvas." Does this mean stretched canvas?
Most are stretched over stretchers, but a number are stretched over a honeycomb panel, to help prevent sagging and movement of a canvas when it is sent about. That [movement] tends to create cracks.

Would you describe your technique?
I know so little. I do what most people do. I look and see what others have to say about it and what they have done. The procedures are simple as far as I can tell.

One last question: What is working with encaustic like for you? Is it a struggle or does the wax just flow?
(Laughs) I wouldn't describe it as either extreme. One proceeds. One watches what happens. Things happen unexpectedly, some that I would be happy to live without. But it has been a pleasure to watch what happens. ●

Elaine Anthony **MILAGRO 40**
mixed media with tin and wax on panel,
30 in. × 30 in., 1996

pigmented wax with a palette knife and fused it with an iron, a modus operandi she continues to develop (along with a growing collection of garage-sale irons). Stuart has also created installations of non-encaustic beeswax sculptures.

In the eighties and into the nineties, wax as a metaphorical "skin" was much in evidence, particularly in the sculptural works of Mia Westerlund Roosen, Elisa D'Arrigo, and Byron Kim, as well as in the mixed-media paintings of the late Elaine Anthony, who worked her surface with an ethereal scrim of wax.

THE NINETIES

The nineties saw an exponential increase in the use of encaustic, and two groundbreaking exhibitions documented it: *Contemporary Uses of Wax and Encaustic* at the Palo Alto Cultural (now Art) Center in Palo Alto, California, in 1992, and *Waxing Poetic: Encaustic Art in America* at the Montclair Art Museum in Montclair, New Jersey, in 1999. Like quotation marks around a statement, these shows virtually opened and closed the decade.

"I brought together what I felt was representative of the different directions an artist could take with the material," says Signe Mayfield, curator of the Palo Alto show. "I think artists had no idea there were so many possibilities." Indeed, the range was satisfying, from a relief in beeswax and lead by Maya Lin, to a wax-and-oil painting on a twelve-inch phonograph record by Squeak Carnwath, to a larger-than-life sculpture of a steam iron in wood, wax, and rubber by Margaret Adachi. Of the thirty-one artists included, fewer than

Michelle Stuart **RIVERRUN . . . SWARDED IN VERDIGRASS**
encaustic, flowers, and pigment on muslin-laminated
rag paper, 55 in. × 77 in., 1986
Collection of Peter E. Haas

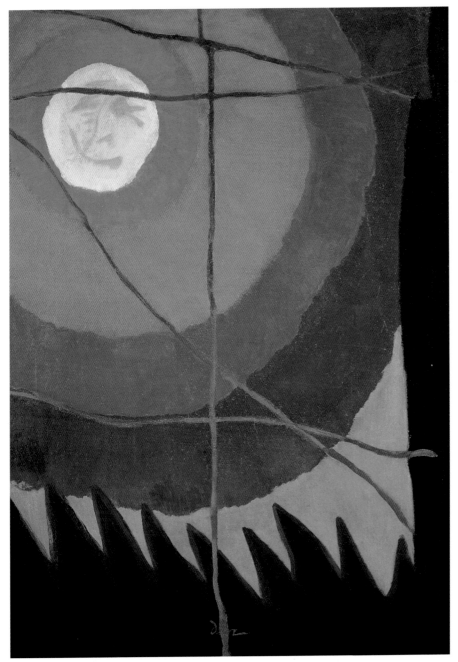

Nancy Graves **APPROACHES THE LIMITS OF**
oil on canvas with encaustic, 84 in. × 64 in., 1978
© Nancy Graves Foundation
Licensed by VAGA, New York, New York

Arthur Dove **CITY MOON**
oil and wax emulsion on canvas, 34⁷/₈ in. × 25 in., 1938
Hirshhorn Museum and Sculpture Garden, Smithsonian Institution, Washington, D.C.
Gift of Joseph H. Hirshhorn, 1966
Photograph by Ricardo Blanc

half specified their work as encaustic. Three who did—Rachel Friedberg, Paul Hunter, and Sabina Ott—were represented in the Montclair show as well.

In *Waxing Poetic: Encaustic Art in America*, the emphasis was squarely on wax set by fusing. "For this show I wanted to clarify the definition of what encaustic is," says Gail Stavitsky, chief curator of the Montclair Art Museum and of the exhibition. In clarifying, she by no means limited the scope of expression, which ranged from figurative to abstract and from two-dimensional—including works on paper—to sculptural.

The show had a nearly decade-long gestation. "For years I'd been noticing encaustic work in galleries, and of course I knew the work of Jasper Johns," says Dr. Stavitsky, "although I had no idea how many people were actually working with the medium." Armed with a list of "better known artists"—including Stuart, whom she calls "a catalyst"—she contacted galleries, got referrals, and began several years of studio visits, most in the New York City area. The result was a well-reviewed show of works by fifty-two artists, fully documented by

CONTEMPORARY USES OF WAX AND ENCAUSTIC
Installation view: Palo Alto Art Center,
Palo Alto, California, 1992

From left: Icon for Farmers, *Susan Marie Dopp;* House After the Poem, on Angels *and* House After the Poem, Churchyard, *Deloss McGraw*

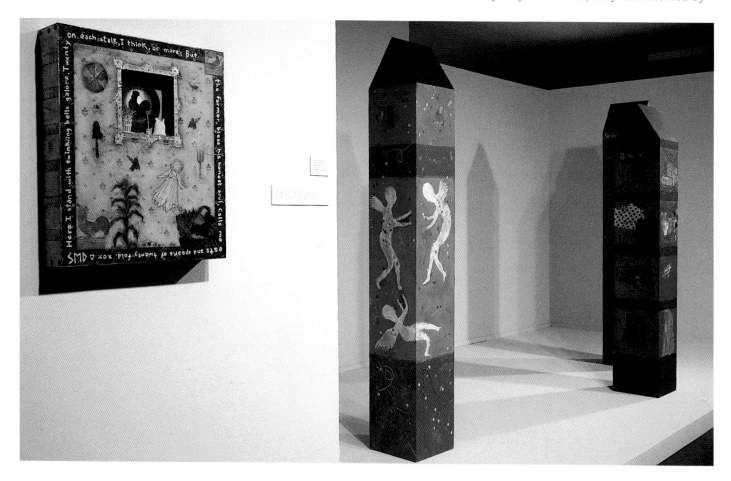

an accompanying catalog—a first for encaustic—with scholarly essays by Stavitsky, art historian Danielle Rice, and artist/paintmaker Richard Frumess.

ENCAUSTIC IN THE TWENTY-FIRST CENTURY

Contemporary encaustic painting—that is, painting made with pigmented wax—is not separate from contemporary art, for, as we know, it is not paint that makes the painting, but the artist. In this new century, as encaustic loses its novelty status, encaustic history and art history will more fully intertwine. Each new painting, exhibition, essay, and review—and certainly, I would hope, this book—will contribute to that history.

Gail Stavitsky's observations, based upon numerous studio visits, are noteworthy: "What impressed me most about encaustic is the union of form and content, and that it seems to be a great vehicle for expressing a range of concerns. You keep hearing that painting is dead, but my visits showed me that a lot of people out there are doing wonderful paintings."

WAXING POETIC: ENCAUSTIC ART IN AMERICA
Installation view: Montclair Art Museum,
Montclair, New Jersey, 1999

Foreground: Petal Piece, *Mia Westerlund Roosen.* Background, from left: Untitled, *Lynda Benglis;* Mont Saint-Victoire Seen from Les Lauves, *Robert Morris;* Appalachia, *Meghan Wood;* Night, *Kay WalkingStick;* Red Swamp, *Joan Giordano*

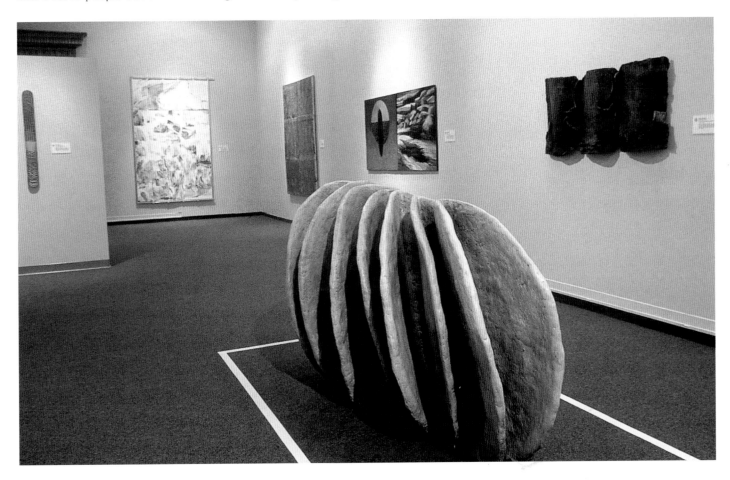

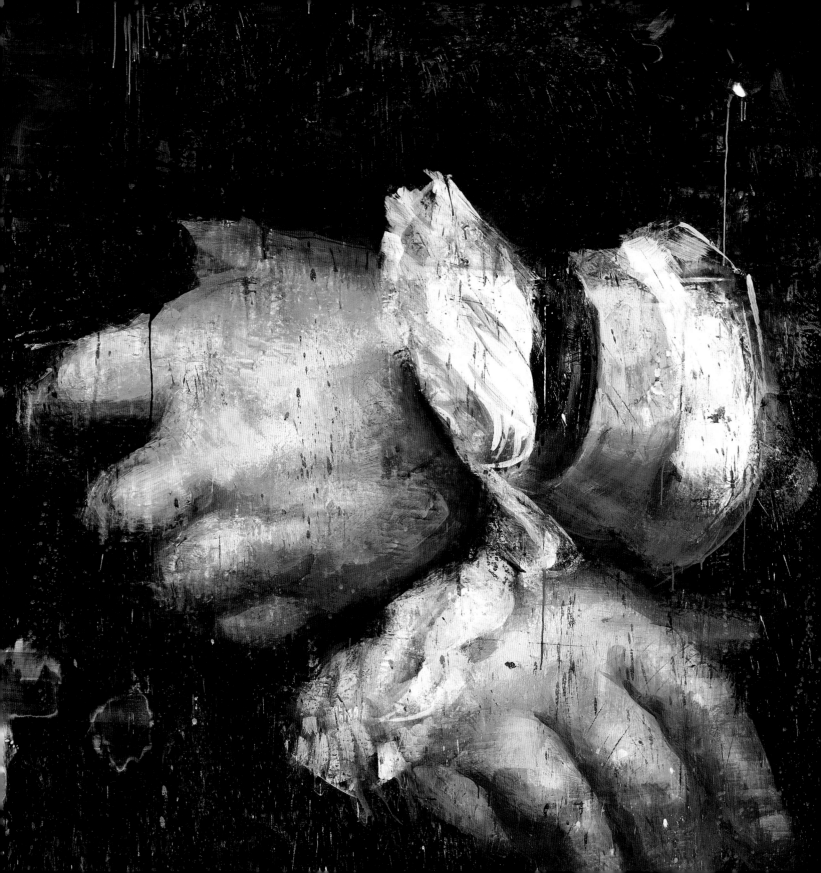

Portfolios

1: Representation

I originally conceived of this chapter as an exhibition, curating the work with brief captions but no text so that images flowed visually, page after page. I wanted you to "walk" the section as you would a museum show (such is the quality of the artists' work). Inevitably, issues arose. How could I convey scale, surface, and dimension when images were flat on a page? I couldn't. What follows instead are four thematic portfolios, each with an introduction that creates a context for the work within.

We begin with Representation. Only a small percentage of contemporary encaustic painting is pictorial, given the recalcitrance of the medium and our tendency toward abstraction. So when we encounter Tony Scherman's larger-than-life portraits, we are stunned not just by their presence but by their very existence; moving closer, we marvel at how his vigorous brushwork, with its riot of smears and drips, can coalesce into such compelling figuration. At the other end of the scale are Amanda Crandall's meticulous, luminously transcendent landscapes, most no larger than a postcard, and some barely larger than a stamp.

Timothy McDowell's botanical landscapes—or are they still lifes?—are poised between representation and abstraction. McDowell achieves his image by painting numerous glaze-like layers on a traditional gesso surface. Leigh Palmer, a painter of landscapes, is represented here with a still life: one perfectly modeled, life-size pear.

With a hint of narrative via pictographic imagery, Tracy Spadafora and Ron Ehrlich arrive at their similar points by different means. Spadafora constructs a story with layers of collage; Ehrlich frees it from under the surface by scraping, gouging, and melting. Rachel Friedberg's enigmatic narratives are recounted by spare figures on a textured, yet spatially neutral ground. Cynthia Winika places an exquisitely limned figure into ambiguously defined space. There is nothing ambiguous about Richard Frumess's serpentine figures: Lush color and suggestive imagery are equally seductive.

OPPOSITE: **Tony Scherman**
THE TERROR: TRICOTEUSE
encaustic on canvas, 84 in. × 84 in., 1998

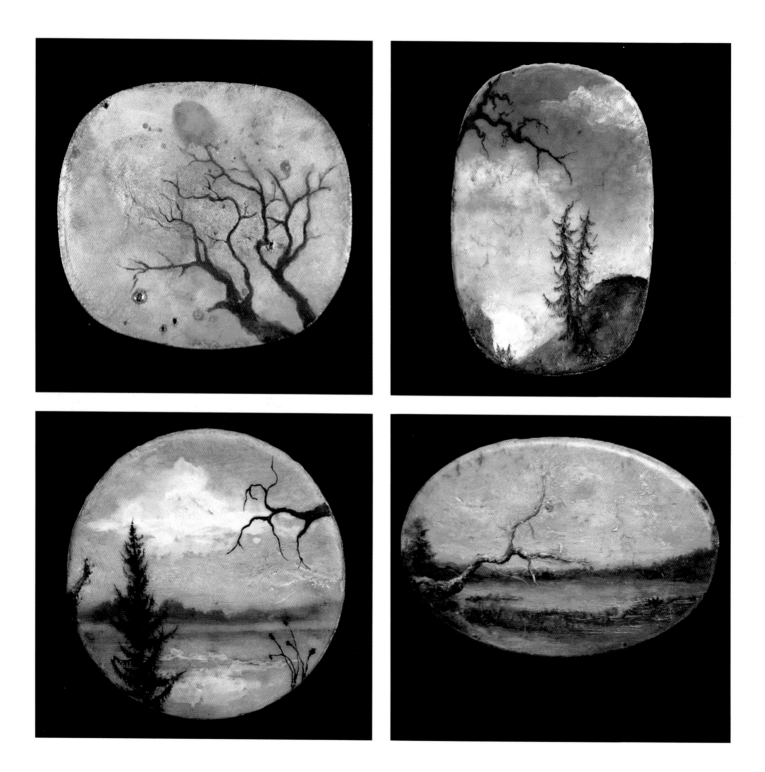

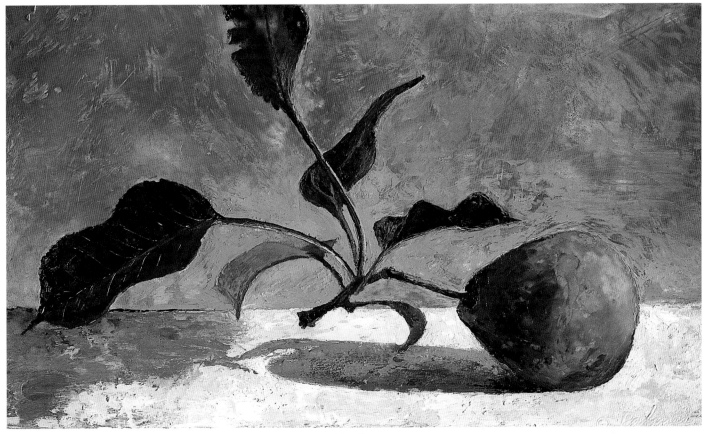

ABOVE: Leigh Palmer **PEARS**
encaustic on braced hardboard, 5³/₄ in. × 10 in., 1995

OPPOSITE, CLOCKWISE FROM TOP LEFT: Amanda Crandall

LANDSCAPE #103
oil and encaustic on birch plywood, 2 in. × 2¹/₄ in. × 2¹/₄ in., 1998

LANDSCAPE #105, STEWART ROAD
oil and encaustic on birch plywood, 6¹/₂ in. × 4¹/₂ in. × 2¹/₄ in., 1998

LANDSCAPE #116
oil and encaustic on birch plywood, 2 in. × 3 in. × 2¹/₄ in., 1999

MISSISSIPPI #1
oil and encaustic on birch plywood, 4 in. (diameter) × 2¹/₄ in., 1999

All works (except *Mississippi #1*): Collection of Linda Hamilton

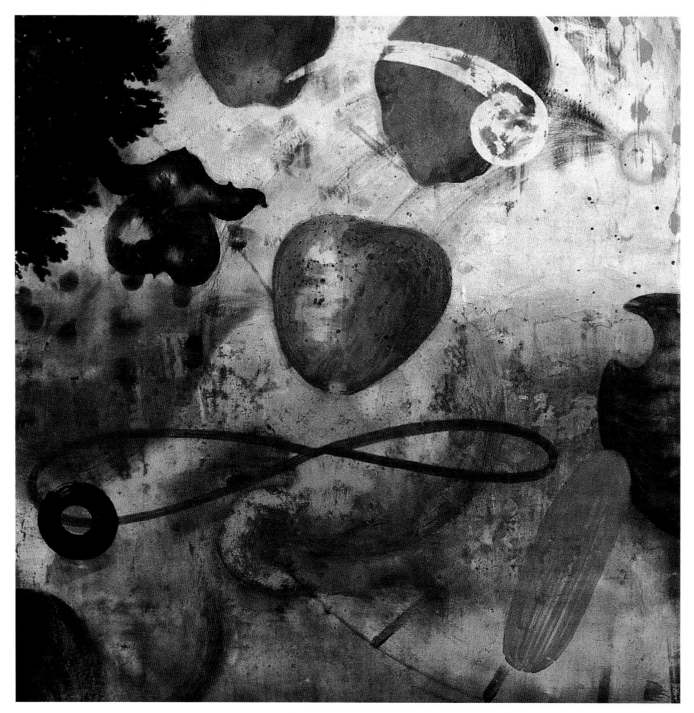

Timothy McDowell **CYCLE**
encaustic on birch plywood, 24 in. × 24 in., 1997
Collection of J. P. Morgan Chase & Co.

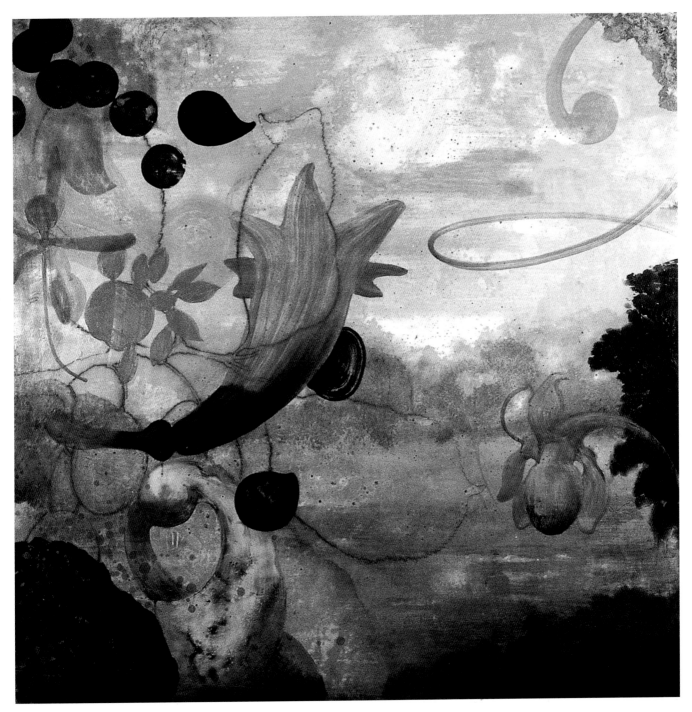

Timothy McDowell **ARCADIAN TRIBUTE**
encaustic on birch plywood, 48 in. × 48 in., 1998

Tony Scherman **ABOUT 1789: ALBERT SPEER**
encaustic on canvas, 72 in. × 72 in., 1997

Tony Scherman **ABOUT 1789: CHARLOTTE CORDAY**
encaustic on canvas, 40 in. × 40 in., 1997

Rachel Friedberg **HIGH CHAIR (NOTEBOOK SERIES)**
encaustic on birch plywood, 20 in. × 20 in., 1992
Collection of Wallace Cunningham

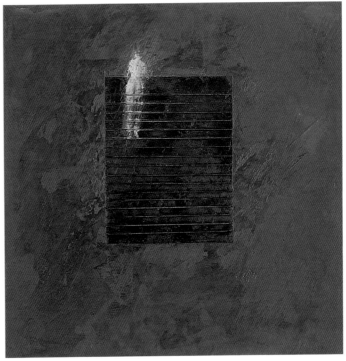

Rachel Friedberg **LA BELLE NOISEUSE (NOTEBOOK SERIES)**
encaustic on birch plywood, 20 in. × 20 in., 1991
Collection of Frederick and Tina Valauri

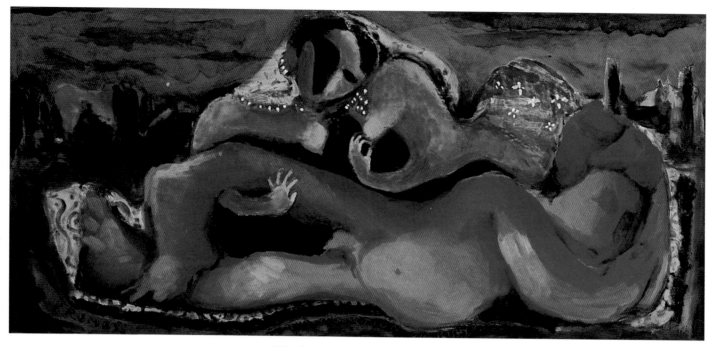

ABOVE: Richard Frumess **THE SEDUCTION OF RIBYK**
encaustic and oil on canvas, 18 in. × 40 in., 1984

OPPOSITE: Cynthia Winika **HELEN ON STAIR**
encaustic and oil on braced lauan, 10 in. × 10 in., 1999

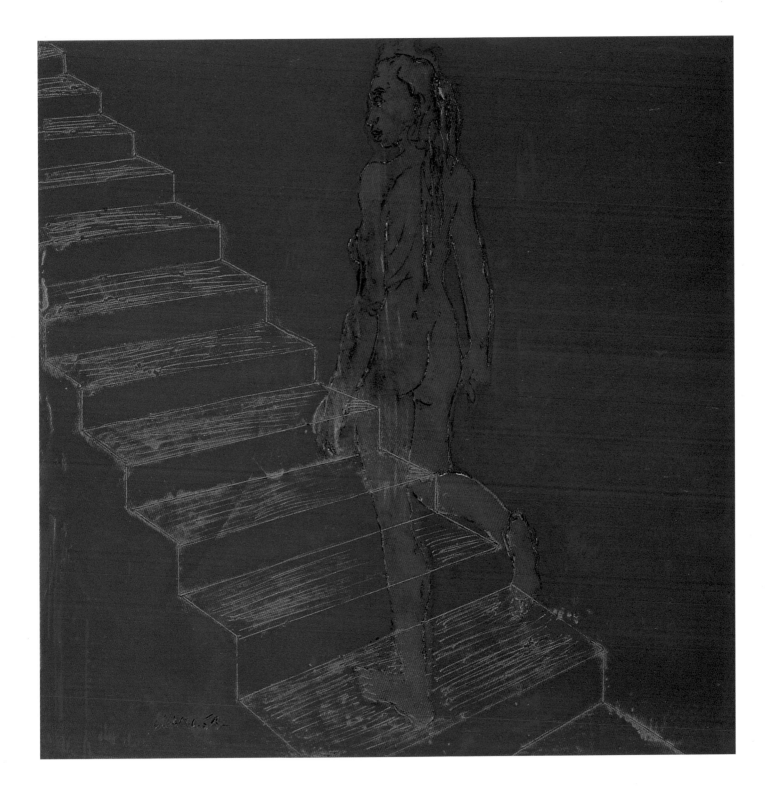

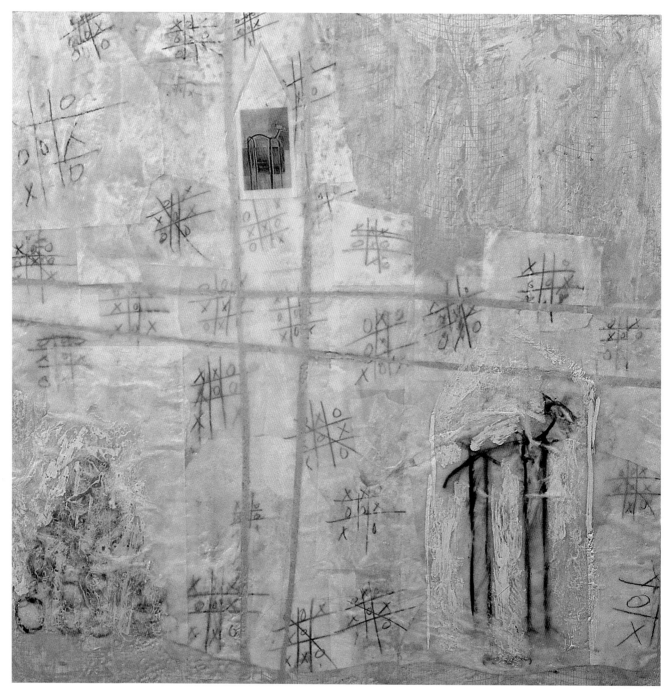

Tracy Spadafora **LONG-LEGGED DOG**
encaustic and collage on braced plywood, 24 in. × 24 in., 1997

Ron Ehrlich **UNTITLED**
oil, wax, and mixed media on panel, 71 3/4 in. × 71 3/4 in., 2000

2: Color and Pattern

Our largest portfolio is united by the most seductive of elements: color and pattern. In some instances, the two merge gloriously; in others, they remain chastely, but no less effectively, apart. (I trust we can agree that the portfolio construct leaves plenty of room for other connections—that pattern can be richly textural, that diptychs can be squirming with pattern, that figuration can be luminously aglow, and so forth.)

When flatness of pattern challenges the dimensionality of wax, the visual tension is exquisite. Witness the embedded gingko leaves of Mari Marks Fleming's *Intervals, 5*, the hovering ovals of Karen J. Revis's *Home*, and the lush grid of Sabina Ott's *Particularly for Pleasure*. Likewise, a spark is set off when dimensionality of pattern, real or perceived, plays against the relative flatness of the wax, as the paintings of Chris Kelly (opposite), Lynda Ray, and Tom Sime make clear. Perspective adds to the image vs. material mix in Nina B. Marshall's *Pavimenti and Bugs* as well as Laura Moriarty's vertiginous diptych, *Whole Wide World*.

With works in a more restrained palette, pattern dominates. Cheryl Goldsleger's *Transparent* is an elegant study in control. Other works in this vein include the pared-down pattern in paintings by Don Maynard and Lawrence Argent. In the mixed-media collaborative work by Patrick Weisel and myself, a grid of straight pins imposes order on snail-like trails of thread imbedded in wax.

In Tremain Smith's *Place of Wisdom*, pattern pulls you in, but the imagery holds you; in Benjamin Long's seemingly allegorical *Up the Stairs*, exactly the opposite is true.

Finally, Eric Blum's juicy canvases with numerical titles, Stephanie Brody Lederman's *Portico Vases*, Orlando Leyba's *Ejido Series #8*, Olivia Koopalethes's *Cryptic*, and my own *Disperse* are rich in many aspects: composition or surface or atmosphere. But they illustrate another principle: When color dominates, everything else is just along for the ride.

OPPOSITE: **Chris Kelly WATER MUSIC**
encaustic on linen on braced lauan, 24 in. × 24 in., 1998
Collection of American Consulate, Ho Chi Minh City

Mari Marks Fleming INTERVALS, 5
beeswax, oil, pigment, and gingko leaves on plywood, 18 in. × 18 1/2 in. × 2 1/2 in., 1997

Cheryl Goldsleger **TRANSPARENT**
wax, oil, and pigment on paper, 22 in. × 22 in., 1999

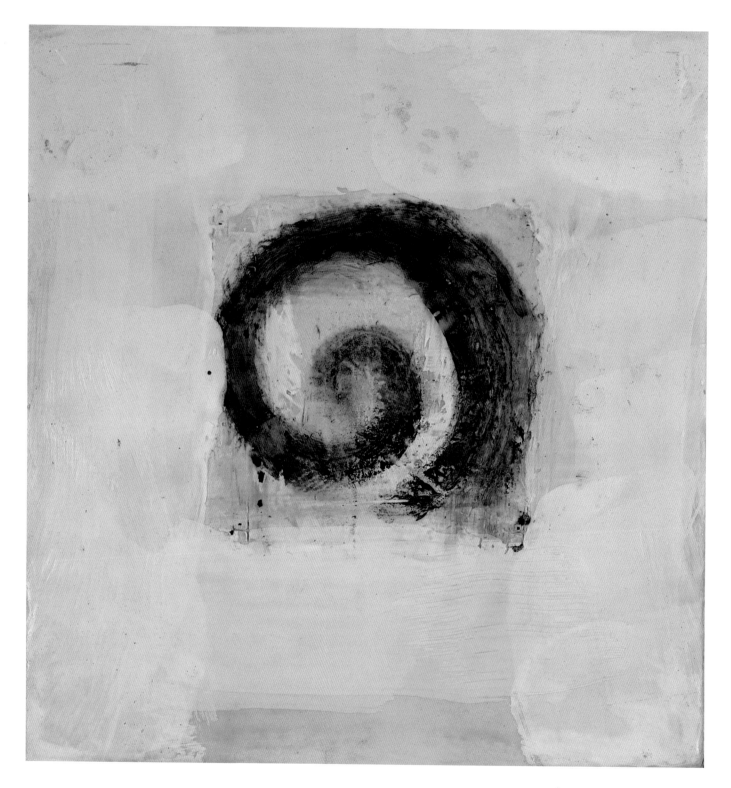

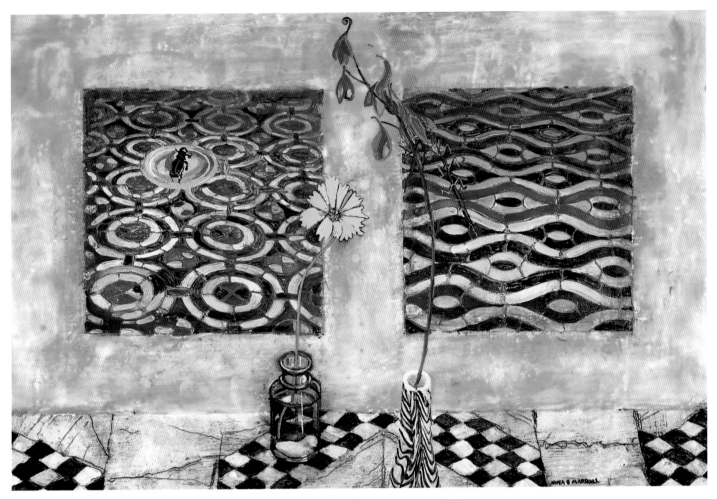

ABOVE: Nina B. Marshall **PAVIMENTI AND BUGS**
encaustic on paper on Masonite, 24 in. × 36 in., 1999
Collection of Minnetrista Cultural Center, Muncie, Indiana

OPPOSITE: Don Maynard **SMALL SPIRAL**
encaustic on canvas on panel, 12 1/2 in. × 12 in., 1998

Lynda Ray **HARMONY OF THE MACROCOSM**
encaustic on braced lauan, 14 in. × 18 in., 2000

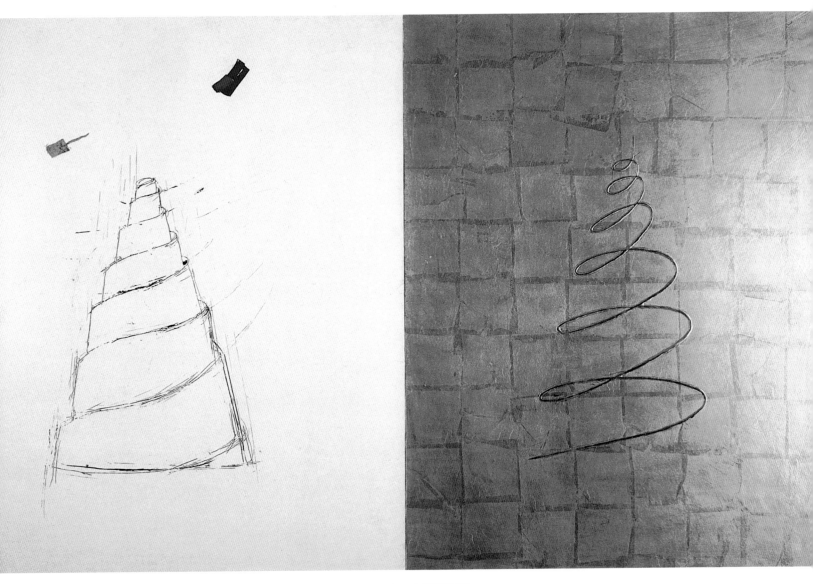

Lawrence Argent UNTITLED
encaustic and gold leaf on panel, 32 in. × 49 in. × 2 in., 1996
Collection of Sergi Gomis and Fanta Watson

Karen J. Revis **HOME**
encaustic on Plexiglas,
7 in. × 5 in., 1998

Tom Sime **PROGENY**
oil, beeswax, and paraffin on
canvas, 10 in. × 8 in., 1994

Joanne Mattera **DISPERSE**
encaustic on canvas on braced lauan, 48 in. × 48 in.,1996

Patrick Weisel and Joanne Mattera
SYMBIOSIS I
beeswax, thread, and pins on Plexiglas,
12 in. × 12 in., 1995

Patrick Weisel and Joanne Mattera
SYMBIOSIS V
beeswax, enamel, thread, and pins on Plexiglas,
12 in. × 12 in., 1995

Laura Moriarty **WHOLE WIDE WORLD**
encaustic on hollow-core door panels;
diptych: 40 in. × 64 in., 1999

Eric Blum **N. 341**
oil, alkyd, and beeswax on canvas, 9 in. × 9 in., 1998

Eric Blum **N. 301**
oil, alkyd, and beeswax on canvas, 9 in. × 9 in., 1995

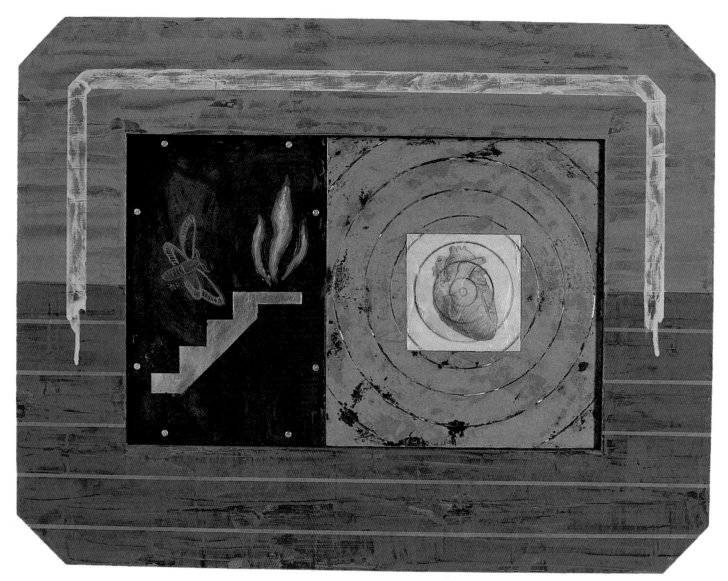

ABOVE: Benjamin Long **UP THE STAIRS**
encaustic and mixed media on Masonite and birch plywood, 21¹/₂ in. × 28 in., 1999

OPPOSITE: Tremain Smith **PLACE OF WISDOM**
wax, oil, and collage on panel, 27 in. × 27 in., 2000

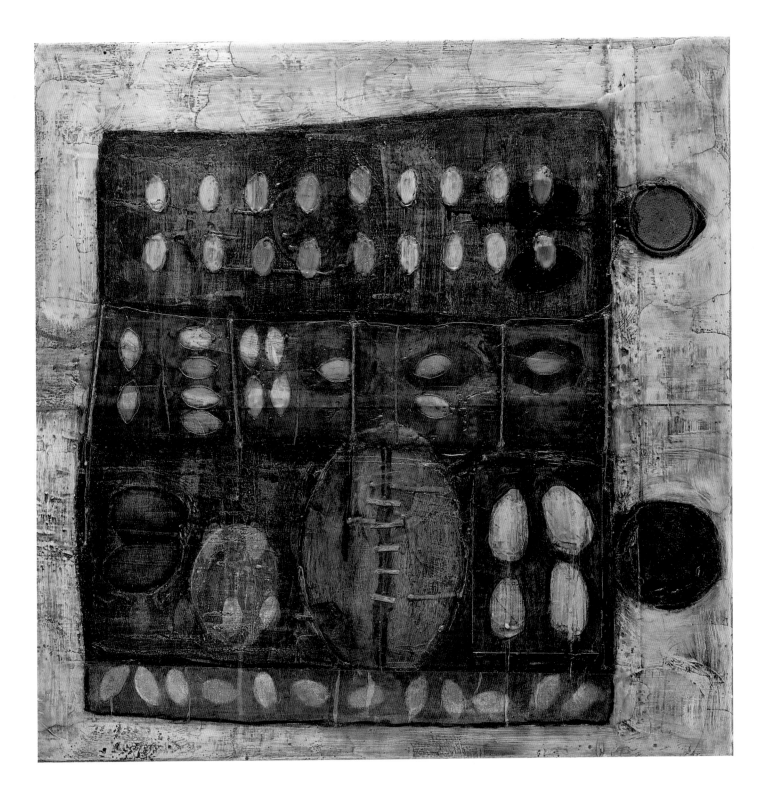

Stephanie Brody Lederman
PORTICO VASES
encaustic on paper on panel,
15 in. × 12 in., 1998

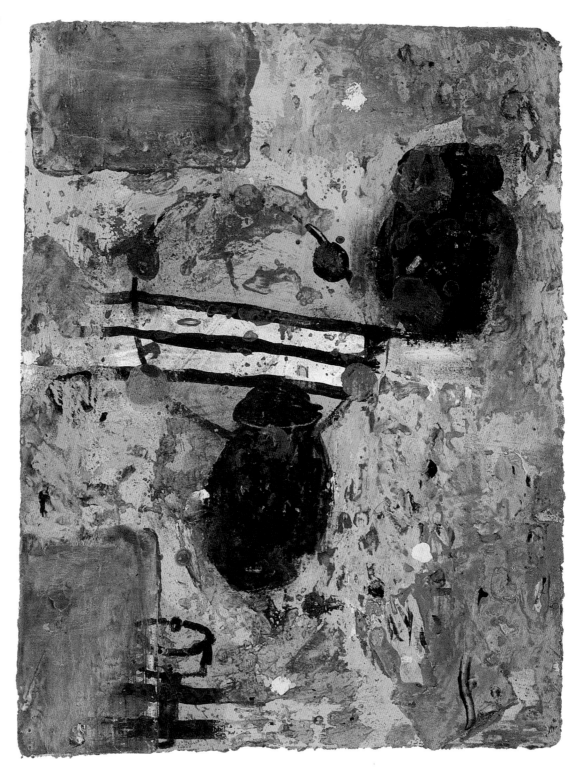

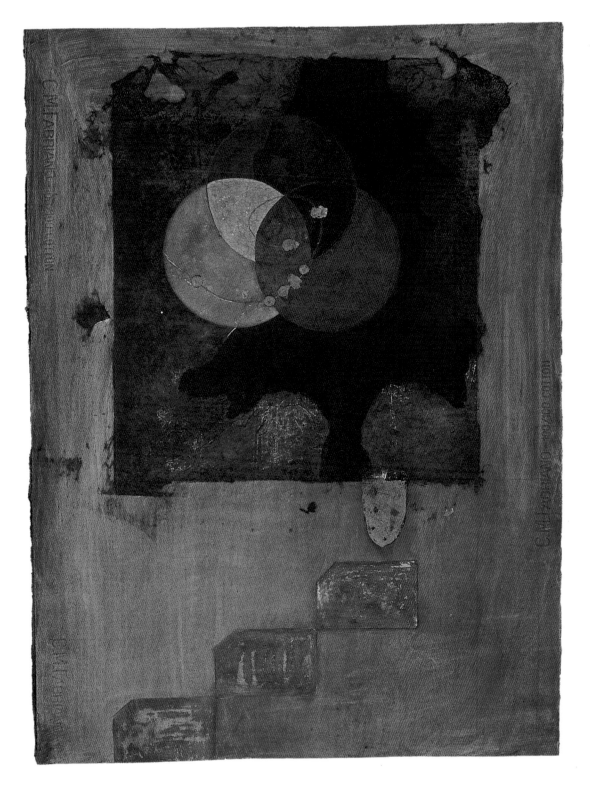

Orlando Leyba **EJIDO #8**
encaustic and mixed media on
paper, 30 in. × 22 in., 1995

ABOVE: Olivia Koopalethes **CRYPTIC**
encaustic on cloth on board, 9 in. × 10 in., 1998

OPPOSITE: Sabina Ott **PARTICULARLY FOR PLEASURE (SHE MAKES HOURS)**
oil and encaustic on panel, 84 in. × 72 in., 1999

3: Dimension

Even on the flattest of planes, wax has materiality and thus dimension. Glazed or layered surfaces have both optical and physical depth. In this section, though, we look at the dimensionality that exists not below that flat plane, but above it. That's why work like Mari Marks Fleming's *Intervals, 5* and Tom Sime's *Progeny*—dense as they are—are shown elsewhere, while Peter Flaccus's *Siena*, a flat pattern with barely raised ribbons of wax, appears here. This is where you find the work of artists who conjure the wax up from flatness: assertive texture rising to low relief, then higher to geographic topography.

What's interesting is the diversity of approach. Lorry Newhouse casts forms in wax and then fuses them to a flat wax surface. Martin Kline, Robin Rose, and Bill Zima work by accretion, forging dimensionality via the texture of repeated drops or brushstrokes, while Miriam Karp does that and less—which is to say she skives into her surface as often as she builds it up, *Re-Excavation* being a case in point.

Not surprisingly, sculptural references are strong. "My paintings come out from the wall. I think of them as sculpture," says Karp. Kline has similar sentiments: "I'm able to be a painter thanks to wax. But I've also become a sculptor again." In his *Culture*, stalagmites of wax grow from the surface.

Fully dimensional sculpture requires an underlying structure, so, ironically, the most freestanding encaustic work is comprised only of a wax skin. Sylvia Netzer painted colored microcrystalline over the fired clay forms of *Miasma Morph*. In the work of Mia Westerlund Roosen and Nancy Azara, the effect is one of actual skin: For the room-size *American Beauties*, Roosen painted fleshy wax over concrete; in her carved book, *Passages*, Azara poured wax to form life-size handprints or footprints on a "page."

Pamela Blum works more intimately in *Forgotten Fruit V*, painting the surface of objects that want to be held—by the eye if not actually by the hand. In the amusing *Ida's Urn*, Gene Kraig daubed wax onto an actual appliance. Just don't plug it in.

OPPOSITE: **Martin Kline GREEN BLOOM**
encaustic on panel, 30 in. × 30 in. × 4 in., 1999
Collection of Marla Prather

Bill Zima **QUANT**
encaustic on hollow-core
door panel,
32 in. × 26 in., 2000
Collection of Dan Missey

Robin Rose **FOR THOSE THAT HAVE DIED FOR ME**
encaustic on linen on honeycomb panel, 72 in. × 48 in., 1999

Miriam Karp **ELABORATE LOSSES**
encaustic on braced lauan,
43 in. × 24 in., 1998

Miriam Karp **RE-EXCAVATION**
encaustic on braced lauan,
78 in. × 48 in., 1998

Lorry Newhouse **UNTITLED**
encaustic on linen on panel, 48 in. × 48 in., 1999

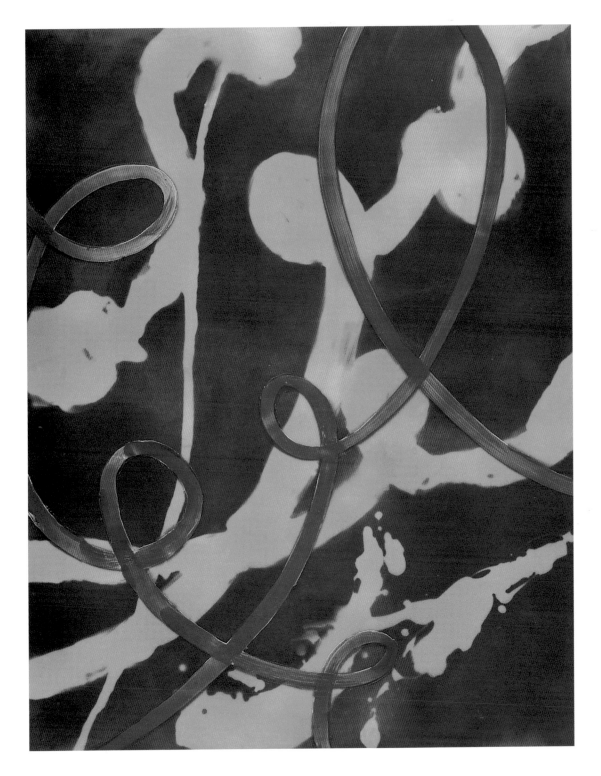

Peter Flaccus **SIENA**
encaustic on plywood,
24 in. × 18^1/$_2$ in., 1998

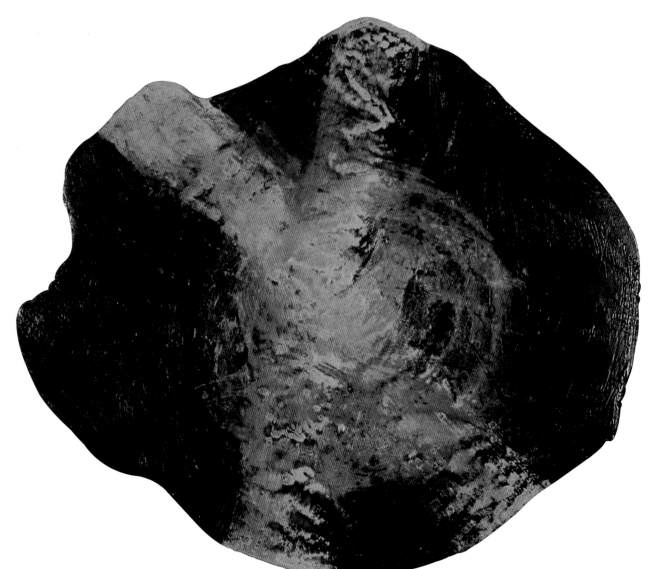

ABOVE (DETAIL) AND LEFT (INSTALLATION VIEW): **Pamela Blum**
FORGOTTEN FRUIT V
encaustic on basswood; detail: 9 1/8 in. × 8 1/16 in. × 1/4 in.;
installation: 71 1/4 in. × 106 1/4 in., 1998

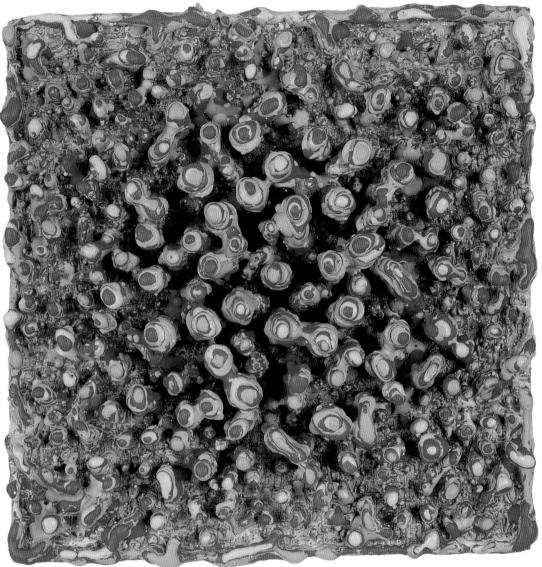

LEFT AND BELOW (TOPOGRAPHICAL VIEW):
Martin Kline CULTURE
encaustic on panel,
7 in. × 7 in. × 3 in., 1998

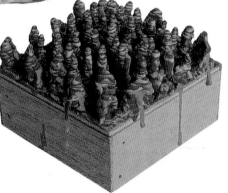

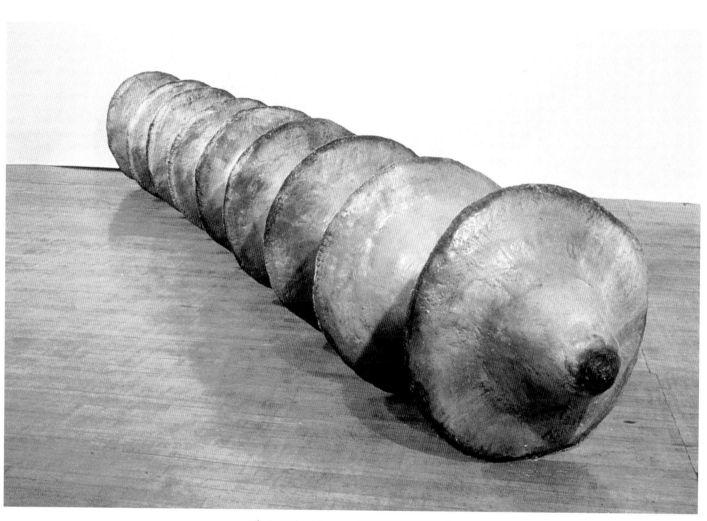

Mia Westerlund Roosen **AMERICAN BEAUTIES**
encaustic on concrete, 24 in. × 24 in. × 240 in., 1990

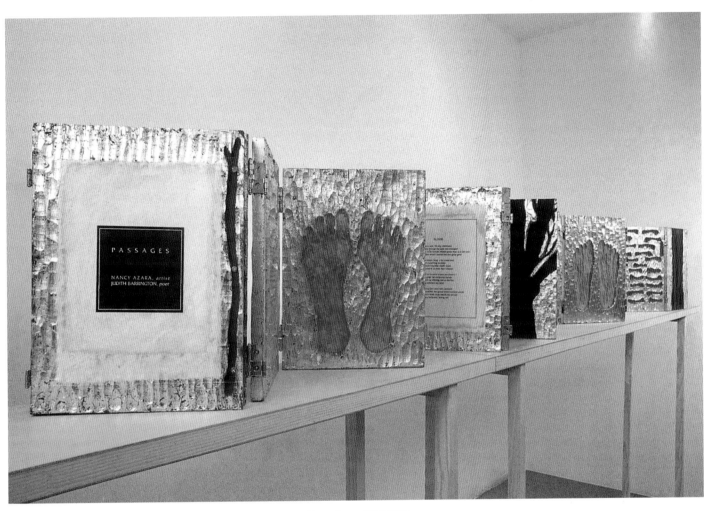

Nancy Azara **PASSAGES**
carved and painted wood with encaustic and gold leaf,
with poems by Judith Barrington, 15 in. × 216 in. (open) × 1 in., 1999

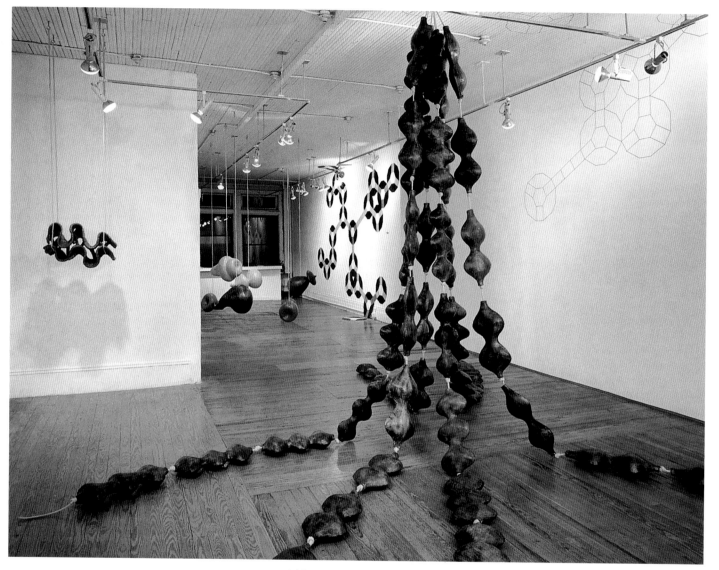

Sylvia Netzer **MIASMA MORPH**
wax and pigment on fired ceramic; room-size installation: dimensions variable, 1996

Gene Kraig **IDA'S URN**
encaustic on coffee urn,
19 in. × 10$\frac{1}{2}$ in. × 10$\frac{1}{2}$ in., 1995
Collection of Howard and
Lee Shapiro

4: Diptychs, Triptychs, and Modular Work

The theme here, separate elements joined to create a whole, resonates on several levels. Conceptually, it acknowledges the ambition of the artist to push beyond boundaries. Visually, it acknowledges the dialogue created by interaction. Functionally, it acknowledges process, safety, and fragility. (The functional issues are addressed in Large-Scale Encaustic Painting, pages 130–131, so here we focus on aesthetic intent.)

Speaking for myself, I can say that what began as a purely pragmatic gesture, borne of the limitations of arm span and studio space, has evolved into an extension of my aesthetic. I typically pit opposing elements against one another—order against chaos, for instance, or austerity against sumptuousness. My multipanel works—in this section, *Azul*—allow me to create raucous visual conversations with a conciliatory premise: agreeing to disagree.

Reconciliation is also expressed in the work of both Johannes Girardoni and Kay WalkingStick. "I am interested in creating work that is both unsettling and fulfilling—pieces in which dichotomies find a way of working with one another," says Girardoni, who often uses the detritus of urban life as an armature. His work is about the physical and the spiritual and "the vibrant energy at the intersection of these two realms." Similarly, WalkingStick brings together symbolic and pictorial images—spiritual and material—in a two-element piece, the spiritual half of which is always painted in wax.

The paintings of Barbara Ellmann and Gail Gregg are composed of disparate panels whose installation amplifies their formal composition. The whole is greater than the sum of its parts. Reinforcement by repetition—the wax-on-Plexiglas paintings of Heather Hutchison, the hand-sewn sculptures of Elisa D'Arrigo, the mixed-media installations of Michelle Stuart—create a similar gestalt.

The mixed-media installation *Indian Flats*, by painter Sara Mast and her partner, sculptor Terry Karson, gives encaustic painting the opportunity to really stretch and flex: sixteen panels totaling eight feet high and nearly twenty feet long.

OPPOSITE: **Barbara Ellmann ROYAL TOUCH**
encaustic on birch plywood;
installation: 64 in. × 64 in., 1998

Heather Hutchison **NINE HIGH**
beeswax and pigment on Plexiglas,
91 in. × 54 1/2 in. × 3 1/2 in., 1993

Heather Hutchison **THE EQUALIZING OF SPACE**
beeswax and pigment on Plexiglas, 33³/₄ in. × 102 in. × 3³/₄ in., 1999
Collection of Victoria Love Salnikoff

Gail Gregg **MOCLIPSE**
encaustic on panel, 24 in. × 24 in., 1998

Gail Gregg **TURK**
encaustic on panel, 24 in. × 24 in., 1998

Kay WalkingStick **WITH LOVE TO MARSDEN**
oil and wax emulsion on canvas, 32 in. × 64 in., 1995

Johannes Girardoni UNTITLED
encaustic and wood, 32 1/2 in. × 48 1/2 in. × 5 in., 2000
Collection of MGM Grand Inc.

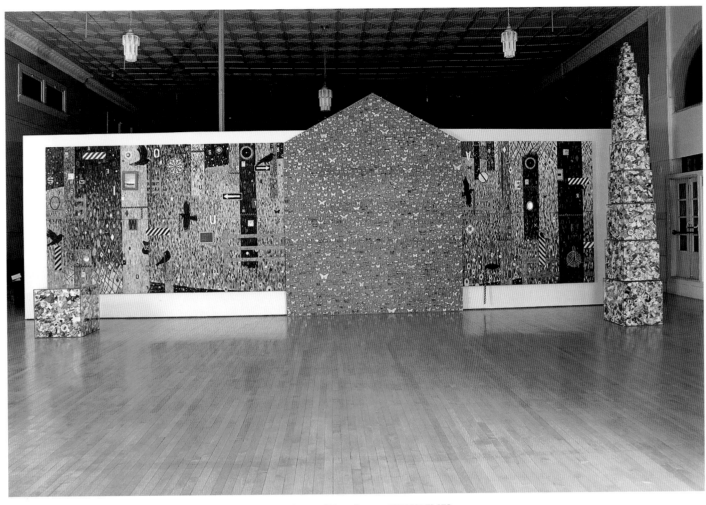

Sara Mast and Terry Karson **INDIAN FLATS**
Painting by Mast in this collaborative installation with Karson
encaustic and mixed media on plywood panels;
installation: 160 in. × 480 in. × 48 in., 1999

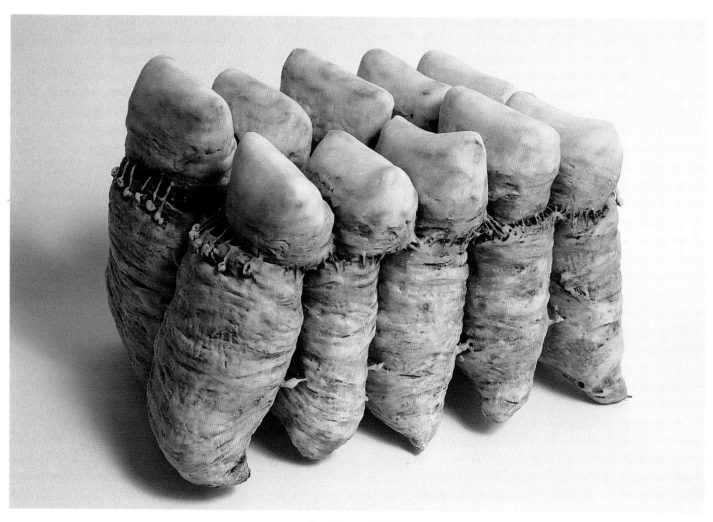

Elisa D'Arrigo **SPLIT #7**
cloth, wax, wire, acrylic medium, thread, and pigment,
9 in. × 10 in. × 14 in., 1998

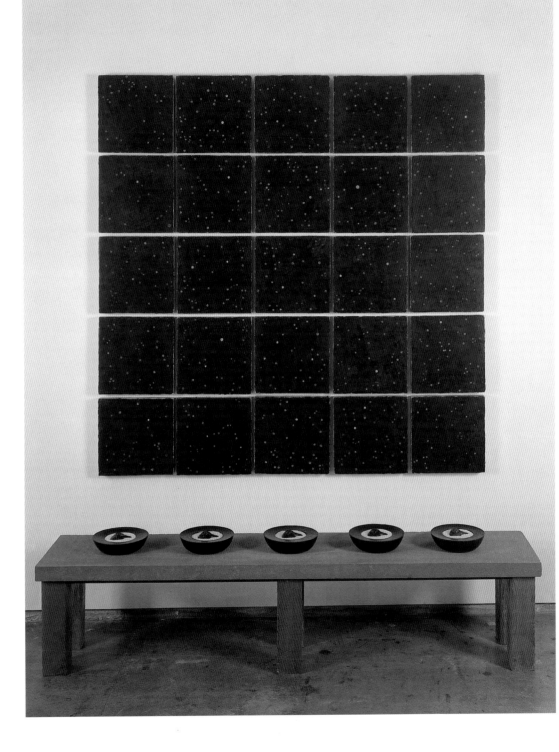

Michelle Stuart **SHEEPS MILK AND THE COSMOS**
beeswax, pigments, stone, and wood;
wall: 62$\frac{1}{2}$ in. × 62$\frac{1}{2}$ in.;
table: 15$\frac{1}{2}$ in. × 71$\frac{3}{4}$ in. × 14 in.;
containers: 8 in. (diameter) × 2$\frac{1}{2}$ in.,
1999

Joanne Mattera **AZUL**
encaustic on canvas on three braced lauan
panels, 48 in. × 87 in., 2001

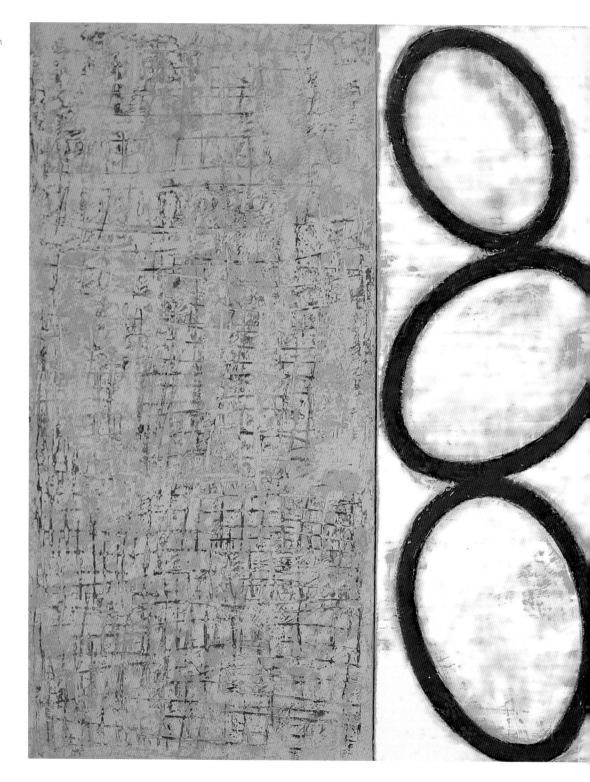

Materials for Encaustic

The basic formula for encaustic can be summed up in six words: melt wax, add pigment, paint, fuse.

Every artist whose work appears within these pages has some variation of the formula, none as simple as I've stated, but none particularly complex. A few artists learn the basics of encaustic in a painting materials class; some, in a workshop. Most pick it up it on their own. "I never went to encaustic school," says Stephanie Brody Lederman, speaking for the majority. So artists have dug out useful bits of information from standard references and then forged ahead adventurously with Crock-Pots, hot plates, travel irons, and an assortment of tools scavenged from disciplines as disparate as wood-working and dentistry.

I have enlisted a variety of art and industry experts to address the questions that everyone asks—what kind? how much? how hot? how thick? how strong? how safe? how archival?—and have included the works and voices of other artists to address a range of materials and techniques wider than I am familiar with. The result should confirm or clarify what you already know, while providing an organized reference for information that is new to you. You'll find Q & As, lists, charts, and tips that let important facts jump out at you while the text proper provides a broader or deeper context for the information.

This book is not about *how* to paint but how to paint *with encaustic*. There are a surprising number of ways to get wax onto your painting surface (or off it), and more ways still to fuse it. There are also a variety of painting grounds you can employ. It's not that one method, tool, or ground is intrinsically better than another, but that a particular one may be better for *you*, depending on how you work (horizontally, vertically, small, large), the way you handle the wax (additively or subtractively), and the kinds of pictures you paint.

**MELISSA MEYER
AT THE GARNER TULLIS STUDIO, MANHATTAN**

In a collaboration with master printer Garner Tullis, Meyer created encaustic paintings on paper with the look of watercolor and the density of encaustic. Here she works horizontally at the adjustable-temperature heat table.

ABOVE (FULL VIEW) AND OPPOSITE (DETAIL): **Melissa Meyer
WHITE STREET (E39)**
encaustic on paper, 22 1/2 in. × 30 in., 1997
Collection of Garner Tullis

Wax

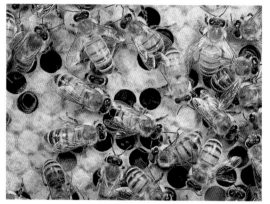

HONEYBEES IN THE HIVE

Bees extrude wax from special glands to form a comb and later to encapsulate their honey within each cell of the comb. Although beeswax is naturally clear white, pollen brought by the bees into the hive every day turns the wax bright yellow to dark brown.

Wax has cut a wide swath throughout history as preservative, polish, paint, salve, light source, and more. Even in our plastic-laminated, silicone-lubricated twenty-first century, not a day goes by that wax is not a part of our lives—in cosmetics and pharmaceuticals as well as protective coatings of all kinds, from glossy magazine covers to M&M's.

Wax comes from animal, vegetable, and mineral sources. Molecular structure varies, but all waxes share these basic qualities: They are relatively inert, they are more resistant to moisture than any other natural material, and their low melting temperatures—most less than the boiling point of water—make them easily workable in the studio.

Artmaking employs but a small number of waxes, and encaustic painting a smaller number still. Beeswax, prized for its lustrous surface and sweet aroma, has been proven over time to be an ideal medium for pigment. It is far and away the preferred medium for encaustic, although microcrystalline offers a viable alternative, particularly with regard to plasticity and price. Other waxes are used in smaller measure.

BEESWAX

Honeybees are the only creatures that make beeswax. Theirs is a lively enterprise. In the United States each year, their keepers retrieve four to five million pounds of wax. The combination of biology and energy is astonishing, for it takes two million flowers to yield one pound of honey, and six to ten pounds of honey to yield one pound of wax.

RIGHT: **WAXES FOR ENCAUSTIC**

Encaustic employs a small number of natural and manufactured waxes. Chief among them is beeswax. *It can be seen in various forms on and in front of the large refined slab, at left. From back to front: bright yellow nuggets, lightly refined; a chunk of crude right from the apiary; moderately refined as pastilles (flat beads), a one-pound cake, and,* foreground, *granules. The granules on the right are as white as refined wax can get.*

In the center *are the waxes for tempering. Background:* carnauba *in refined flakes and chunks of dark crude. Below it are refined* candelilla *flakes. In the foreground: chunks of powdery-looking* damar resin.

Petroleum waxes are at far right. At the back: *two slabs of translucent* paraffin; *brittleness is apparent where the edge has begun to chip. In the foreground: a chunk and a cake of* microcrystalline. *The chunk had been in my studio for some time; note how oxidization has given it a cast yellower than the new slab beneath it.*

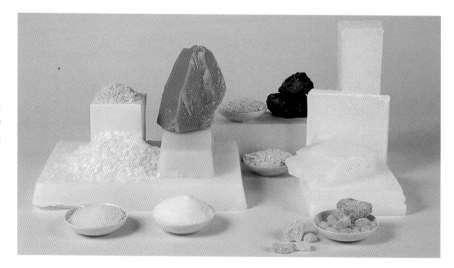

In the hive, wax forms the comb, which contains honey in its hexagonal cells. As some bees turn flower nectar into honey, others extrude wax to seal the comb cell by cell. By harvest time, the seal—called a *capping*—is a sheet about one-sixteenth of an inch thick that covers the entire comb. Beekeepers slice the cappings off the combs, selling both honey and wax through a cooperative. (Harvest takes place when the bees are gone; on their return, the insects begin honey production anew.)

Refining and Bleaching

Beeswax is clear white when secreted, but it is soon turned a golden hue by thousands of pollen-covered bees that pass over the comb as they go in and out of the hive each day. The longer the wax remains in the hive, the darker it becomes. Even yellow wax has been lightly processed, if only to remove propolis (bee glue), moisture, and dirt.

Mechanical refining returns the wax to its natural state by filtering out the yellow pollen and propolis. A clay/carbon mixture (not unlike fine kitty litter) is added to the hot liquid wax. "The ingredients act like a sponge to pick up the colorants," says John Dilsizian, owner of Dilco Refining in Maspeth, New York. The ingredient-laden wax is forced through a press that contains filter-paper sheets, set at intervals to attract the clay/carbon granules along with the colorants they have attracted. The newly clean wax passes into a holding tank, and the used filters are removed so that a new batch of wax can be refined. The process is low-tech, non-toxic, and environmentally friendly.

Chemical bleaching turns the wax white by oxidation. Phosphoric acid and potassium permanganate decolorize the liquid wax without actually removing the colorants. If the wax is not light enough after treatment, it is bleached with hydrogen peroxide. "Chemical bleaching is a very effective way of whitening crude waxes for industry, but for artists it may alter the wax," says Dilsizian.

- The wax may revert to yellow, since the colorants are not removed.
- Traces of residual chemicals could alter the color of the pigment you add.
- The wax's structure may become weaker, resulting in a more brittle wax.

Quality

While bleaching can lower the quality of wax for painting, bees themselves produce wax of better and lesser quality, just as they do different types and grades of honey. Dilsizian lists these variables: the particular strain of honeybee, the types or quality of crops it is pollinating, even weather that is too wet or too dry. You have a better chance of getting top-quality beeswax if you or your supplier knows the source of the wax.

Q & A

Q: Refined beeswax, bleached beeswax—what's the difference?

A: You'll find a thorough explanation in the text, but here's the short answer: *Mechanical refining* removes the pollen and propolis, which give wax its yellow color, by filtering. *Chemical bleaching* uses strong ingredients to decolorize the contaminants. Since "bleached" is often used to describe both methods of cleaning, clarify with your supplier exactly how the wax has been processed.

Q: Will white beeswax ever revert to its natural color?

A: White *is* beeswax's natural color. When pollen and propolis are removed by filtering, the wax returns permanently to its natural state. Chemical bleaching is not so stable. "That wax *can* revert to yellow," says John Dilsizian, owner of Dilco Refining in Maspeth, New York.

Q: Can I really sun-bleach beeswax?

A: Filtered wax, yes. And the longer you keep it in the sun, the whiter it will become—permanently. Flakes and beads bleach more quickly than thick slabs because the ultraviolet rays have a shorter distance to penetrate. Wax is not affected by moisture, so it can remain outdoors for days or weeks.

Sun-bleaching won't have much effect on a block of dark crude; it's best used to make an already refined wax whiter. Also, sunlight doesn't mean high noon in the middle of August; if the wax melts, leaves and dirt may settle into it.

Q: Can I mix waxes?

A: "All the waxes, including beeswax, are totally compatible," says Dilsizian. ➤

Q: What are good beeswax mixes?

A: That depends on what you want. To lower your cost, add microcrystalline to beeswax. A blend of 50 percent beeswax, 25 percent microcrystalline, and 25 percent hard paraffin is entirely workable, says Dilsizian. Microcrystalline is so plastic that it can handle the paraffin without the mix becoming brittle. To make beeswax harder, he suggests 2 to 3 percent carnauba or 3 to 4 percent candelilla. "With a blend you can create the kind of surface you want, and you can adjust the consistency so that it melts at a particular temperature," says Dilsizian.

If you experiment with mixes, Dilsizian offers this advice: "Do it on a small scale. And keep a record of what you do, so that when you find a formula you like, you can make it again."

Q: What form of wax is the best?

A: That's a matter of preference. Bigger units, such as slabs and cakes, are cheaper than flakes (shaved from a slab), beads (droplets plopped onto a conveyor belt and hardened), or granules (liquid wax sprayed into an air-cooled tower and congealed as tiny droplets). The larger units are easier to store but harder to break (freeze a slab, then whack it with a hammer). Quick-melting beads and granules can be poured or scooped, but you must transfer them to a secure container to avoid spillage (a plastic bin on wheels works just fine).

Q: What's the best wax for glazing?

A: Pharmaceutical-grade beeswax, used in lipsticks and salves and to coat pills, is the clearest, most filtered wax available. If you work transparently, this is the best wax to use. ➤

Waxes Used in Encaustic—A Quick Reference

Wax	Source	Composition
Beeswax	The honeybee, *apis mellifera*, or other related honeybee species; bees secrete wax to contain and enclose the honey produced in the hive	Primary ingredient: melissyl palmitate acid, along with other wax acids, esters, and alcohols, and about 10 percent hydrocarbons
Candelilla	The scales of a reedlike plant, *euphoribea cerifera*, which grows wild in Texas and Mexico; the resinous wax protects the plant from its desert climate	Wax acids, esters, and alcohols, with about 50 percent hydrocarbons; the highest resin content of all the natural waxes
Carnauba	The palm, *copernica cerifera*, which grows in northern Brazil; the tree exudes wax through its leaves, berries, and stalks to conserve moisture in an equatorial climate	Primary ingredient: melissyl cerotate ester, along with other esters, acids, and alcohols, and about 2 percent hydrocarbons
Microcrystalline	Refined from petroleum; "it's close to natural wax," says Dilco's John Dilsizian. "All the refiner does is extract the excess oil and other impurities"	One hundred percent hydrocarbons; derives name from its structure, a matrix of extremely small crystals
Paraffin	Refined from petroleum	One hundred percent hydrocarbons; the higher the melting point, the harder and heavier it is

Properties	Melting Point	Flash Point	Color Range	Average Price Per Pound
Relatively plastic, flows well in molten state; its encapsulative quality makes it an effective medium for pigment; easily scraped and incised; luminous, fragrant	143.6–149°F	468°F	Clear to white as secreted by bee; pollen turns the wax yellow; aged crude can be dark brown	$5–15
Hard and brittle; lustrous; due to its significant resin content, does not reach maximum hardness until several days after cooling	155–162°F	465°F	Light yellow to light brown; refined through filtering and bleaching	$6–8
An effective natural moisture barrier, the hardest of the natural waxes; buffs well; does not cloud; extremely brittle; best used in small amounts to temper beeswax	180.5–187°F	570°F	Yellow to brown; refining lightens it, but it will impart a yellow tone to clear beeswax	$6–8
Microcrystalline for encaustic is more plastic and slightly tackier than beeswax; though refiners add an antioxidant, the wax will yellow slightly over time; mineral odor	140–205°F, depending on product	450°F and up	Color depends on degree of refining; for encaustic it is clear	$2–5
Consistency varies, depending on formulation; overall it is brittle, prone to cracking and chipping; can be used to temper a soft microcrystalline; relatively odorless	118–165°F, depending on molecular structure	380°F and up	Clear	$1–2

Q: Can I use damar varnish instead of crystals when tempering wax?

A: Not a good idea. Crystals are 100 percent damar resin. Varnish contains damar dissolved in turpentine; it's easier to use, but the turpentine fumes are toxic, particularly when heated.

Q: Why do my dark paintings get dustier than the lighter ones?

A: That dusty surface is *bloom*, not dust. Bloom is caused by a chemical reaction, particularly prominent when using ivory black or alizarin pigments with chemically bleached wax. "The free fatty acids in chemically bleached wax combined with the free calcium in these pigments—ivory black is made from charred bones—can combine to create bloom," says Richard Frumess, founder of R&F Handmade Paints, which uses only filtered wax.

Q: How do I get rid of bloom?

A: Just wipe it off with a soft cloth as necessary. Eventually the reactivity will cease and the bloom will be gone. A second kind of bloom occurs when untempered beeswax has been exposed to below-freezing cold. Frumess explains, "Unsaturated hydrocarbons migrate to the surface and crystallize."

To remove this bloom, gently reheat the surface of the painting. To prevent it, avoid extreme cold. Or temper wax with damar, microcrystalline, or linseed oil, which contain saturated hydrocarbons. (Note: Linseed oil will make wax softer.)

Q: I heated beeswax in a cast iron pot and it turned brownish. Why?

A: Wax stored or heated in iron vessels takes on the color of the iron. The chemical change caused by the iron won't harm the wax, but the color cannot be removed. ●

MICROCRYSTALLINE

There is little history of encaustic with microcrystalline. This petroleum-based wax, produced in consistencies from soft and tacky to hard and brittle, was developed only seventy-five years ago. For encaustic, you need a formula with pliability and a slight tack. Unless you have a source that specializes in encaustic materials, you may be disappointed in the quality of microcrystalline that you find; most art supply stores have selected a general-purpose version for use in casting, batik resist, and other creative work. To find the best formula for your painting—do you paint thickly or thinly? do you work *alla prima* or scrape and incise the surface?—ask your source what options are available.

Microcrystalline contains varying amounts of oil, thus the range of plasticity. "The oil will oxidize on exposure to light, turning a white wax to yellow over time. For this reason, refineries add preservatives to the wax to slow down oxidation," says Dilco's John Dilsizian. If you pigment the wax, yellowing is not a problem, but it could be if glazing with clear layers is a priority.

Microcrystalline's plasticity is a powerful draw for Tony Scherman, who paints up to eight by nine feet on stretched canvas. You may find, as he did, that "microcrystalline will change your life." But, he'll tell you, "It stinks." There will be more to be said about this wax as artists begin to explore its advantages and circumvent its drawbacks.

CARNAUBA AND CANDELILLA

These two waxes are exuded by desert plants to retain moisture. They melt at high temperatures (compared to other natural waxes), and the surfaces they form are hard and highly protective. Carnauba is the hardest of the natural waxes; candelilla, the one with the highest resin content. How hard are they? Flakes in a plastic bag have the crispiness of potato chips, while beeswax beads, by way of comparison, feel somewhat like al dente pasta. If you use either of these waxes, use them only to harden beeswax—they are far too brittle to be used alone. Many artists use about 10 percent (one part in ten), but Dilsizian suggests a smaller amount: no more than 5 percent.

PARAFFIN

This mineral-based wax diffuses light brilliantly, and at about a dollar a pound it is downright cheap, but it is extremely brittle and so not a good choice as a medium. Still, it has some practical applications. It might be used to temper a soft microcrystalline, says Dilsizian, and it is an inexpensive brush cleaner.

Naturally, there's an artist to test the edges of every limitation. Tom Sime (see sidebar) uses paraffin extensively. Working small, he has produced paintings with exquisite surfaces and ethereal light refraction.

ENCAUSTIC MEDIUM

Depending on the material, a tempering agent can make beeswax softer or harder. For encaustic, a hardening agent makes a better beeswax—more durable, thus more scratch resistant; and more adhesive, thus easier to fuse. Moreover, it helps guard against crystallization, known as *bloom*, which can occur if the painting is exposed to extreme cold, such as in an unheated studio or during frigid transit conditions.

Tempered beeswax is usually referred to as *encaustic medium*. You can experiment with various blends of carnauba or candelilla, or you can use a natural resin.

There are many kinds of natural resins, but damar, the hardened sap of a fir native to Malaysia and Indonesia, is the one widely used for encaustic. Top-quality No.1 Singapore is nearly clear, although it will yellow slightly with time. A more immediate problem: Even "clean" damar contains plant and insect material that must be removed. If you can, select the chunks yourself and pick out the cleanest ones.

A Simple Formula for Making Encaustic Medium

Add one part damar to eight parts beeswax. Work in small batches. Monitor your temperature with a candy thermometer. You'll be less likely to splash the wax if you keep your containers half full. Please read the Safety with Materials section (pages 106–109) before proceeding.

- Melt the wax in a large, non-iron container, ideally stainless, with sturdy handles. Wax melts at 150°F, but you will need a temperature of 225°F for the damar to melt.

- Add the crystals. Smaller pieces melt more quickly, so it's wise to crush them first. (I place the chunks inside a double plastic bag, whacking them with a wooden mallet until I have powder; then I sift it in a fine strainer to remove as much of the plant material as possible.)

- The damar will crackle and become sticky on its way to a full melt. Stir it thoroughly into the wax. Then stir continually until you can see and feel an even consistency. At that point, lower the heat to a more wax-friendly 180°F. (Alternatively, you could melt the damar in a separate pot with a smaller amount of beeswax and add this mixture to the full volume of wax. It's easier on the wax—and safer for you. When I do it this way, my main container is a Crock-Pot, and I use disposable baking pans for the wax/damar mix.)

- Secure a double layer of cheesecloth over a clean container. Pour the liquid through to remove any remaining detritus. (Beware of using nylon pantyhose: The hot wax could melt them.)

Q & A

Q: Can I change the eight-to-one proportions of wax to damar?

A: Sure. Experiment to see what works for you, bearing in mind that the more damar you add, the harder the surface will be. For instance, more than one part of damar in four will make the wax too brittle, and thus too fragile—your edges may crack—while sprinkling only a few crystals or a bit of damar powder will have a negligible effect on the wax.

Q: What do I do about those tiny bits of plant matter that stay in my encaustic medium, no matter how well I strain it?

A: Those tiny particles tend to sink to the bottom of a cake of wax medium. After I pop the cakes out of my muffin tins, I rub the bottom surface of the new cakes on a heated griddle, one by one, wiping the "melt" with a piece of cheesecloth. The grit comes off with that wipe. ●

MAKING ENCAUSTIC MEDIUM

Any vessel with a spout makes pouring the wax much easier (and safer). Here, a Teflon-coated saucepan was used to pour encaustic medium into Teflon-coated muffin tins. The uniform size of the tins works as a measure for paintmaking. Caveat: Once you use a kitchen utensil for artmaking, do not use it again for cooking.

Beeswax but Not Encaustic: Emulsion

When is beeswax not a medium for encaustic? When it has been emulsified: mixed with water by means of ammonia. Kay WalkingStick has been using beeswax this way for nearly thirty years. After preparation, the water-based emulsion requires no heat. "For me, it's a way to use acrylic paint so that it has a beautiful organic quality," she says. WalkingStick refers to Ralph Mayer's recipe (in his book *The Artist's Handbook of Materials and Techniques*), but after so many years she knows the emulsion is right by its consistency: "like cold cream or mayonnaise."

HOW ONE ARTIST WORKS

WalkingStick mixes the emulsion with acrylic paint in proportions of 30 to 40 percent emulsion. "The acrylic is the binder," she notes. She paints with her hands on a stretched, acrylic-gessoed canvas to which she has glued a second layer of canvas for extra support. The thick, almost sculptural impasto dries overnight. "The surface," she notes, "looks very different from encaustic paintings—it's much more matte."

ADVANTAGES AND DRAWBACKS

Emulsified wax requires no melting, no fusing, and no unusual tools. If you are concerned about safety issues in the studio, this water-based medium eliminates just about all of them, except for ammonia fumes in the initial preparation. Conversely, if what you want is the luminosity, process, and aroma of beeswax, you won't find it here. Further, emulsified wax is melted by extreme heat and cracked by extreme cold. "It chips if it's poorly handled, but that's an issue for everyone who uses wax," says WalkingStick. ●

Kay WalkingStick **CARDINAL POINTS**
wax emulsion, acrylic, and glitter on canvas,
60 in. × 60 in. × 3 1/2 in., 1985
Collection of the Heard Museum,
Phoenix, Arizona

"I do not have to heat the wax, so my process is much simpler," says the artist. "On the other hand, my surfaces look very different from other people's wax paintings."

THE EMULSION RECIPE (AFTER RALPH MAYER):

1. Melt one ounce of refined white beeswax with five ounces of distilled water.

2. Separately, mix one-half ounce of ammonium carbonate with enough distilled water to make a paste. Notes Mayer, "A teaspoon of half-strength ammonia water may be substituted."

3. Add it to the wax/water mixture, stirring until the mixture emulsifies and the ammonia fumes are gone. Caution: Ventilate well, as ammonia fumes are toxic. Ideally, you'll work next to an exhaust fan that draws the fumes out without your even smelling them.

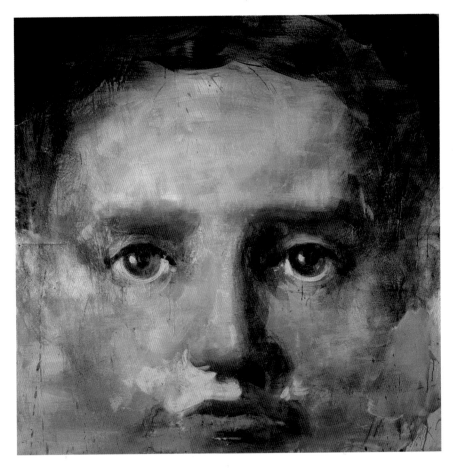

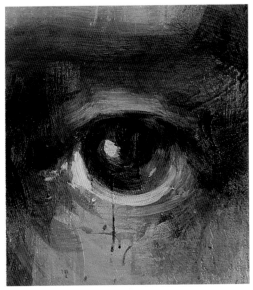

ABOVE (FULL VIEW) AND LEFT (DETAIL):
Tony Scherman
**THE FRENCH REVOLUTION:
NAPOLEON'S FIRST SHAVE**
encaustic on canvas, 60 in. × 60 in., 1995
Collection of Concordia University, Montreal

*"Not a day goes by that I don't curse
the medium. It is so, so difficult. But it
is just so extraordinary. Even after all
these years, it has an unpredictability
that's astonishing."*

Encaustic but Not Beeswax: Microcrystalline

Tony Scherman started working with wax as an art student in 1974. "I did ten paintings before I realized paraffin was too brittle," he says. He found beeswax better, but, after a decade, he started looking for a wax more suited to his needs. "My interest was to paint *alla prima* on canvas. I had to find a way of painting without the wax cracking when it got thick," he says. In 1986 he found microcrystalline wax. "With it, I started to do things I had never before been able to do. My paintings changed dramatically. They got larger and thicker."

HOW ONE ARTIST WORKS

Scherman paints upright at the easel on stretched canvas, working up to an astonishing eight by nine feet. He melts his wax in frying pans on a hot plate and colors it with powdered pigments or oil paint. "Oil paint allows the brush to move a little more easily," he notes. His figuration is rich with strokes that retain the marks of the wax-laden brush. In part, that is because he doesn't fuse every layer. "That's one of the differences between beeswax and microcrystalline—the tack is so good," he says. When he does fuse, it is lightly with an iron. Visually, the two waxes are similar, with luminosity and texture both very much in evidence.

ADVANTAGES AND DRAWBACKS

Microcrystalline can take high heat and return to room temperature without becoming brittle, says Scherman, and it is pliable without being vulnerable. The wax he uses can be worked thickly without cracking. In fact, he rolls his canvases for shipping. Drawbacks? Just one, he says: "I miss the smell of beeswax." ●

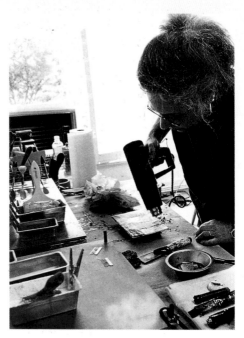

PAMELA BLUM IN HER STUDIO

Both heat stages are visible as Blum works: melting wax on the hot palette (foreground) and fusing it with the heat gun. The heat gun is the tool most widely used by artists because it can be spot-aimed, as Blum does here, or wielded to cover a larger area. (A blow-dryer may look similar, but it cannot deliver heat sufficient to melt the wax.)

Heat

It is not enough to melt the wax for painting; each newly painted layer must be fused to the one beneath it. Fusing, or *burning in*, makes encaustic strong, for wax on its own tends to remain in discrete layers. Melting and fusing typically require different tools. For best results, select equipment that gives you the greatest degree of control.

MELTING THE WAX

Cooking utensils are fine appliances for melting wax. A Crock-Pot keeps your medium warm. An electric fryer melts large amounts of one color. A griddle topped with tuna (or other similarly sized) cans, each can filled with a different color, keeps many colors warm at once. For touch-ups, you can make a good palette with a Teflon-coated stove-top griddle set onto an adjustable hot plate. Working in fresh, small batches maintains the integrity of wax, pigment, and resin, but you can reheat colors if you work at temperatures between 165°F and 220°F.

FUSING THE WAX

There is no one best tool, only the best tool for a particular job:

- A **HEAT GUN** delivers a steady blast of hot air. For Rachel Friedberg, who fuses on a vertical surface, that force keeps the wax from dripping—but on a flat surface, a high fan speed can blow hot wax right off the painting. Skillful handling takes practice.

- A **PROPANE TORCH** is a boon if you're working large because you're not tethered to a cord. But the heat is intense. And do you want an open flame in the studio?

- An **INCANDESCENT LIGHTBULB** (100–200 watts, depending on the size of the bowl reflector and the distance from the work) offers slow, radiant heat. Set paintings under a low-wattage lamp to keep them warm until you're ready for them, to maintain a malleable surface as you work, or to fuse. Caveat: High wattage and close distance can melt wax surprisingly fast.

- An **IRON**—domestic, travel, or tacking—delivers heat right where you want it. Depending on pressure, you can level the peaks of a textured surface or press them completely smooth.

EQUIPMENT FOR MELTING THE WAX

If you work with large amounts of medium or pigmented wax, you'll want to use vessels such as Crock-Pots and electric fryers for melting your wax; with lesser amounts, your needs will be met by small containers on a griddle or on a hot palette. Always look for vessels with sturdy bases and handles and with temperature controls. Teflon-coated equipment allows for easy cleanup.

From left: *a heavy-gauge aluminum hot palette heated by an adjustable hot plate; a stove-top griddle, for use on a hot plate; a ceramic Crock-Pot (one that lifts out of its heating jacket is best); and an electric fryer with temperature controls. (Hot palette and hot plate courtesy of R&F Handmade Paints.)*

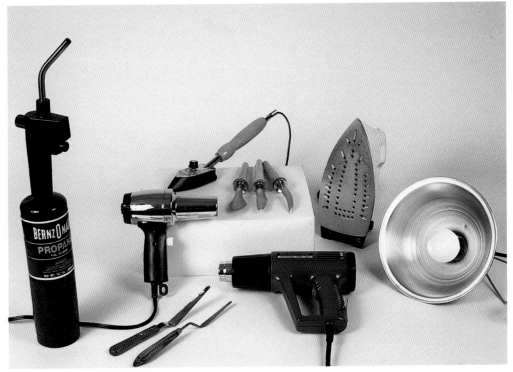

EQUIPMENT FOR FUSING THE WAX

Fusing requires just enough focused heat to join the top two layers of wax. It is a rare painter who employs all of these tools; more likely you'll gravitate toward the ones that work best for you and then learn to handle them with subtlety and control. From left: *a propane torch that lets you move free of a cord; heat guns (best: those with adjustments for air speed, temperature, and degree of diffusion) that are light enough to let you work without muscle strain; a bowl reflector with 200-watt bulb (use with tong clamps or on a lamp stand). Background: a tacking iron, a household iron, and, between them, electric palette knives for spot fusing. Foreground: conventional palette knives, which can be touched to the hot palette for fusing details or small areas. (Blue heat gun, tacking iron, and electric palette knives courtesy of R&F Handmade Paints.)*

Pigment

One of the joys of encaustic is its luminosity. Layers of pigmented wax deliver color in a way no other medium can, for as light passes through those layers and is reflected back up to the surface, the painting is actually illuminated from within.

A QUICK OVERVIEW OF PIGMENTS

The section on Safety with Materials (pages 106–109) includes caveats and safeguards for working with pigments, so here I focus on pigments themselves and how little it takes to turn them into paint.

A pigment is an inert, finely powdered crystalline coloring material that does not dissolve into a medium but remains suspended within it. Artists' pigments must meet American Society for Testing Materials (ASTM) standards for fineness, brilliance, tinting strength, and lightfastness. Otherwise they would be used elsewhere, as housepaint, for instance, where particle size need not be so fine. The same pigments used in oils and tempera can be used with wax.

Pigments are classified as *transparent* or *opaque*, though there is a broad middle ground with an interplay of overtones and undertones, light and dark. If you wish to exploit the luminosity of wax, multiple thin layers of transparent pigments are ideal. You can use opaque colors in encaustic, but, notes the *Gamblin Color Book*, a fine source of information about paint, "Thinning down an opaque color does not increase transparency; it merely puts more space between the particles of pigment."

Mineral pigments encompass any color with metal as a base. They include:

- **EARTH COLORS:** Used by the earliest cave painters, these semi-transparent to opaque iron oxides—green earth, ocher, sienna, umber—remain essential today.

- **MARS COLORS:** These synthetic iron oxides, named for the Roman god of iron, were first made in the eighteenth century. They are created through heat in a range of opaque yellow, red, violet, brown, and black hues. New in this category: transparent earths.

- **SYNTHETIC MINERAL PIGMENTS:** Cobalt, cadmium, and manganese colors are created under heat or with acid. Green, blue, and violet cobalts are transparent to opaque; red and yellow cadmium are opaque; violet manganese is semi-transparent.

Carbon-based *synthetic organic pigments*, sometimes called *modern colors*, are a product of twentieth-century chemistry. Phthalocyanine blue and green, quinacridone red and magenta, and dioxazine purple—all transparent, permanent, and strong—are in this category, as are semi-transparent hansa yellows and naphthol reds.

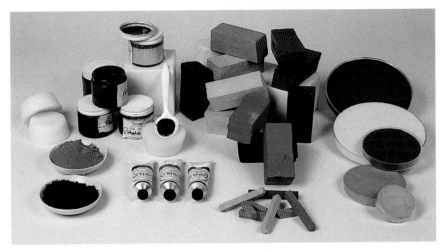

ENCAUSTIC PAINT, AND PIGMENTS FOR MAKING YOUR OWN

Commercial encaustic paint is made from beeswax, damar, and pigment. If you make your own paint, you can color beeswax or microcrystalline with powdered or dispersion pigment. Clockwise from left: pigment powder, which must be handled with gloves and a mask; cakes of encaustic medium, a mix of beeswax and damar; dispersion pigment, a viscous preparation of milled powder and linseed oil that mixes readily into wax; cakes and rounds of ready-made wax paint. Foreground, options for small-scale coloring: oil paint, which will slightly plasticize the wax; oil pastels, made with paraffin, which will make the wax smoother and slightly more brittle. (Paint in cakes and rounds courtesy of R&F Handmade Paints and Enkaustikos, respectively.)

PIGMENTING YOUR WAX WITH TUBE COLOR

You can use oil paint to color any kind of wax. When painter Karen J. Revis uses oils to pigment her beeswax, she first sets the paint onto paper towels for several hours to draw out much of the oil.

Q: How about oil sticks?

A: Oil sticks are an artist's material, made with a small amount of beeswax and a lot of good-quality pigment. If you use them to color wax, keep in mind that the proportion of oil to wax must be small—as with oil paint, about 30 percent—or the wax will be unable to maintain its integrity. A better bet is to think of oil sticks as a material to use *with* the beeswax—to draw on the encaustic surface, to highlight incised lines—rather than as a coloring agent.

Q: Is alizarin more unstable in wax than in other mediums?

A: Alizarin is a *lake color*, one of a tiny number of pigments that started life as a dye. Dyes are soluble, as pigments are not. To make alizarin an insoluble pigment, the dye is precipitated—bonded—onto an aluminum particle. If you use alizarin or any other lake pigment, use it only with mechanically refined beeswax; chemically bleached wax has free fatty acids that can combine with elements in ivory black as well as alizarin. "Until recently, alizarin was the only good cool red," notes Robert Gamblin, president of Gamblin Artists Colors. You can now find entirely stable synthetic alizarin.

Q: I keep hearing that acrylic paint is not to be used with beeswax. Why?

A: Simple: Water-based acrylic paint does not mix into oil-compatible wax.

As for painting, an acrylic surface—and that includes acrylic gesso—is not absorbent enough to accept the wax. The only exception is when beeswax is made into a water-based emulsion, which, as you know (see sidebar, page 96), is not true encaustic. ●

MAKING YOUR OWN PAINTS

There is no formula for encaustic paint because every pigment has a different weight and intensity, and every artist has a different idea of what makes a perfect hue. The broadest parameters: Pigment can be added to wax in minute amounts up to a one-to-one ratio. Typically, you'll need about 20 percent pigment to achieve a brilliant hue.

Pigment comes in two forms. *Powdered* pigments are ground to a certain particle size by the manufacturer. You can hand mull pigments to further break down the particle clusters to make a smoother paint. *Dispersion* pigments for encaustic are milled with a small amount of linseed oil and perhaps a wax-compatible alkyd resin. The result is a dense, viscous pigment in a jar that is ready to be spooned into the wax.

Two Approaches to Paintmaking

Encaustic paint is no more difficult to make than hot cocoa. You'll work with melted wax and your pigment of choice in a heated vessel at a temperature between 165°F and 220°F.

THE HIT-AND-MISS APPROACH: You invent as you go along. Add color, stir, test the hue, add more pigment or not. When you achieve the color you want, begin painting.
Advantages: The results are easy and spontaneous. Surprises can work to your advantage.
Drawbacks: *Without a record of what or how much pigment was added to how much medium, that perfect color might not be reproducible. Bear this in mind if you're making small batches of color for a large painting. Also, some surprises are dreadful.*

THE RECIPE APPROACH: The recipe is your own, attained through experimentation. When you get your color, ladle or pour it into smaller containers. Unless you're custom mixing for a project, make a basic palette. Add white, black, and other colors as needed.
Advantages: With a determined ratio of pigment to medium, the color is reproducible.
Drawbacks: *Making a lot of paint at one time is a chore.*

COMMERCIALLY PREPARED ENCAUSTIC PAINT

The difference between studio-made and commercially made paint is the milling. Richard Frumess, founder of R&F Handmade Paints, explains: "When you open your bag of pigment, you're seeing agglomerates, clumps of particles. The art of milling is breaking down the agglomerates to smaller clusters so that pigment particles are in a colloidal state—in suspension—in the

wax medium. The better the suspension, the smoother the consistency and the greater the luminosity." At R&F Handmade Paints, Frumess does this with a three-roll mill in small, controlled batches. Pigment and medium are run between rollers that move at different speeds so that the pigment particles are forced apart and the wax slips in between them. (This is the process used by other encaustic paintmakers as well.)

You can use commercial encaustics full strength, mix them with other colors, lighten them with white, or dilute their intensity with wax medium. Even if you plan to make your own paints, you owe it to yourself to see how finely milled paints perform—how they feel on the brush and are received by the ground, how they fuse and harden, how they look in a finished work, how they hold up. Prepared paints are a worthwhile investment, for as with oil colors, they let you get right to the business of painting. Equally important, they eliminate some of the safety issues associated with pigments.

GRIDDLE AS PALETTE

For mixing prepared colors or making small amounts of one color, you can use a Teflon-coated griddle heated over a hot plate.

Have you made a color you love? Save a hardened chip of it, along with a note of what you remember about the process, so that you have a chance of reproducing it at a later date. Better still, keep some rudimentary notes as you go along—especially as you're learning how your pigments behave in wax. You'll appreciate these good habits when you are working on a large painting or in a series and continuity of color is essential.

If you work in a Teflon-coated frying pan, as I do, the dark coating will affect your view of the color, so you'll have to dab the paint in progress on a white surface to see how the mix is progressing. (I keep a pad of watercolor paper for that purpose.)

Planning to mix up a batch of paint? Consider Rachel Friedberg's system: she begins with cakes of medium molded in muffin tins. "With same-size cakes, you add the same amount of pigment and get the same color each time," she says.

Can you mix dispersion pigments with powdered pigments or with oil paint? I think simplicity is a better approach when you're making paint. Work with one pigment type and you get to understand how it behaves—how the pigment remains suspended in the wax, how a particular amount of pigment creates a particular saturation, how colors respond to temperature. My primary pigment source is dispersion color, and I don't normally mix ingredients when I'm preparing a batch of paint in the electric fryer. However, once the color is made and I'm working with smaller amounts on a griddle or in little containers, I do mix things up, adding a touch of oil color or some R&F paint to my "house brand." ●

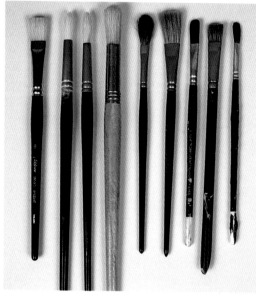

BRISTLE VERSUS HAIR

Wiry hog bristles, left, *stand up better to the heat, but soft hair brushes,* right, *let you lay down the wax lightly or smoothly.*

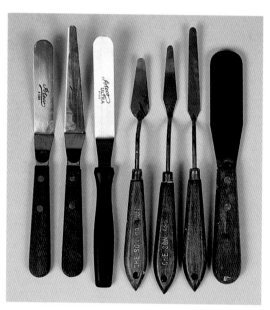

WAX SPREADERS

Palette knives and spatulas are ideal tools for applying wax if you're working at a low temperature (about 165°F) and you want to spackle, slather, or butter a dense surface.

Brushes and Other Applicators

Brushes are the primary painting tool because they come in such a range of sizes, shapes, and resiliencies. But other applicators are worth exploring.

BRUSHES

A basic tenet of painting is to use the best brushes you can afford. Quality bristles set into a well-made ferrule give you a dependable vehicle for loading just the amount of pigment you need to make a controlled mark. Why should it be different for encaustic? Yes, hot wax is hard on brushes, but cheap brushes undermine your control if they don't handle as you expect them to. And loose bristles can become entombed in a freshly cooled brushstroke. Let your painting experience guide you in selecting brushes. You can use most of your tube-paint brushes. Just clean them well before starting.

- **BRISTLE VERSUS HAIR:** Tough, resilient hog bristle, the classic oil painting brush, is ideal for encaustic in straight or angled *brights* and gently rounded *filberts*. If you want a gentler line or smoother surface than bristle gives, try softer hair brushes. I use *pointed round* watercolor sables (actually weasel or kolinsky hair) for dropping dots of wax, and flat oxhair *wash* brushes for glazing. For applying wax grounds I like goathair varnish brushes and flat Chinese *hake* brushes, made from sheep's hair. See what works for you.

- **NATURAL VERSUS SYNTHETIC:** There's no discussion here. Go with natural. Nylon bristles will melt in hot wax.

- **HEAT VERSUS NATURAL HAIR AND BRISTLE:** Very high heat won't melt natural brushes, but it *will* ruin them. It will melt the glue that holds the bristles in the ferrule, or the ferrule to the shaft, and it will singe the hairs so that you end up with what painter Timothy McDowell calls "furballs on a stick." Extend the life of your brushes by not letting them sit in hot wax, and by keeping wax heat under 220°F.

OTHER OPTIONS FOR APPLYING WAX

Don't rule out any tool until you find the one that lets you achieve the image and surface you're after. Blades spread the wax. "I use a spatula all the time," says Michelle Stuart. Heather Hutchison likes the way cheap foam brushes lay down a smooth edge-to-edge stroke. In search of "a tender, eloquent line," Ann Huffman designed an electric version of the *tjunting*, which is used in batik to make fine lines, and a hot wax pen with changeable nibs.

Tip: Basic Brush Care

Tending to your brushes is the easiest part of encaustic painting. One option is to let the wax harden on the bristles, in which case you will collect a palette of brushes to be used with specific colors. Want to use the same brush for several colors? Dip it in paraffin—keep a can of clean wax ready on your hot palette—and wipe the bristles and ferrule with paper towels. Want to totally clean a brush for other uses? "Dip paraffin-cleaned brushes in warm vegetable oil to remove the last of the wax, then wash them with soap and water," suggests Cynthia Winika.

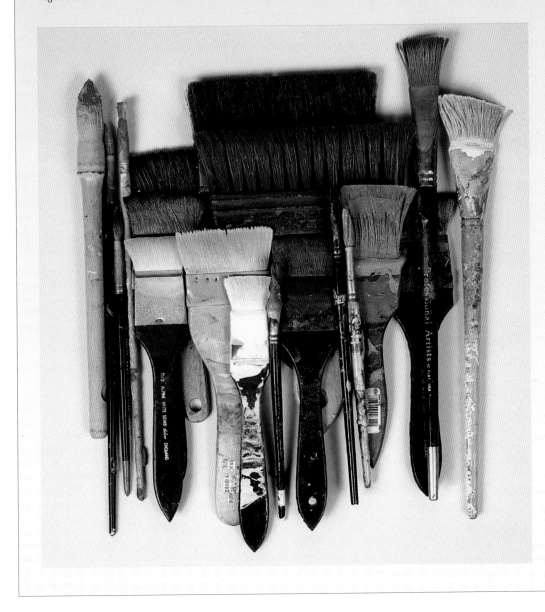

A PALETTE OF BRUSHES
Unlike oil-painting brushes, which must be cleaned after use, encaustic brushes are not harmed by hardened wax. However, you are limited to using them with specific colors or within a color group.

Safety with Materials

"**N**o artists were ever harmed by materials they weren't exposed to," says Monona Rossol, an industrial hygienist and author of *The Artist's Complete Health and Safety Guide*. Simply put: Take the appropriate precautions and you'll be safe.

BASIC STUDIO SAFETY

Keep a clean, organized studio. Most toxins build up in the body over many months or years, so you might not become aware of a problem unless you become ill.

- **VENTILATE PROPERLY:** For encaustic, an open window is not enough: You need an exhaust fan to pull out wax vapors and pigment dust. A three-speed window fan, facing out while you work, is adequate; a louvered industrial fan, installed permanently, is better. Make sure you have air coming in to replace the air going out; for this you can use an open window at the far end of the studio. Your work area must be between you and the fan so that toxins do not pass your nose on their way out.

- **SEPARATE STUDIO ACTIVITIES FROM EVERYTHING ELSE:** Scrupulous safety requires that you not eat or smoke in the studio. Realistically, if you spend eight hours or more there, you'll get hungry. Designate a food area to be permanently free of artmaking materials, and wash your hands before eating or drinking. Change out of your studio clothes when you leave for the day; you'll keep toxic materials from going home with you, where they could contaminate your dinner, your pets, or your kids. If you live and work in the same space or house, isolate hazardous materials—and never use the domestic kitchen for artmaking.

- **KNOW THE HAZARDS OF YOUR MATERIALS:** Read warning labels and follow the directions. Many manufacturers list their 800 numbers; call if you have questions about a product. One helpful resource is Arts, Crafts and Theater Safety (ACTS), Monona Rossol's non-profit organization. Contact it to request information on specific hazards—ask for the monograph *All About Wax*—or to find an occupational clinic near you. (This type of clinic is familiar with the effects of artists' materials.) Contact ACTS at 181 Thompson Street, New York, New York 10012, or via e-mail at actsnyc@cs.com.

THREE SMART WAYS TO VENTILATE

In each of these studios, heating equipment sits directly under or next to the exhaust so that fumes and vapors immediately vent out. Heather Hutchison's domestic fan (left) is secured within the window frame. My own industrial fan (center) is permanently installed; louvers eliminate drafts when the motor is off. The kitchen hood in Timothy McDowell's studio (right) vents into a chimney flue.

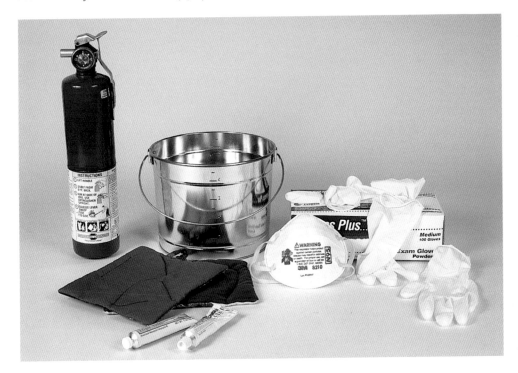

BASIC SAFETY EQUIPMENT

An exhaust fan is just one type of safety precaution. Other measures, from left: to put out a small wax fire, an all-purpose "ABC" extinguisher, as here; for burn treatment, a bucket of ice water and burn creams (also good are aloe and vitamin E); potholders to prevent burns while handling hot vessels or tools (also useful are oven mitts and tongs); for pigment protection, latex gloves and a particle mask.

WAX

Any wax in solid form poses no safety problem, either as raw material or as finished painting.

Safety hazard: Beeswax heated above 250°F (and other waxes at forty to fifty degrees above their melting points; refer to the chart on pages 92–93) begins to decompose, giving off acrolein, formaldehyde, and other dangerous gases, vapors, and fumes. "The higher the heat, the greater the breakdown of these substances," says Rossol. "There is no respirator to protect you from them." Acrolein irritates the respiratory tract—sinuses, throat, and lungs—and chronic exposure may increase your risk of allergies, colds, or bronchial ailments. Chronic exposure to formaldehyde may cause respiratory allergies or even cancer. Headaches, a cough, or a sore throat suggests you're being affected, but, says Rossol, "not everyone exhibits these symptoms."

Safety hazard: Wax condensate, a cloud of fine wax particles hovering over too-hot wax, could ignite explosively from a spark, static discharge, or your propane torch.
Resolution (for both hazards): *This is easy. Turn on the exhaust fan the minute you turn on the heat so that emissions and condensate will vent outside and disperse. Monitor temperature, but know that if your wax is smoking, it is too hot, no matter what the gauge says.*

Safety hazard: Hot wax can cause severe burns.
Resolution: *Melt only the wax you need. Your vessel must be secure and not full to the rim. To lower the risk of wax burns while painting, wear coveralls or jeans and long sleeves, and shoes instead of sandals.*

TOOLS FOR MELTING AND FUSING

Appliances pose their own hazards. See Fire Safety in the Studio (sidebar, page 106) for additional tips.

Safety hazard: Thrift shops and garage sales are a great source of Crock-Pots, electric fryers, chafing dishes, and the like, but cords, plugs, handles, and legs could be unsafe.
Resolution: *Replacing worn cords and plugs is cheap and easy; have the hardware store clerk show you how when you buy the materials. Pass up any appliance that can't stand on its own or, just as bad, whose handles are missing or can't be tightened.*

Safety hazard: The rheostats on some old appliances no longer work.
Resolution: *If you can't control the temperature of the appliance, get rid of it.*

PIGMENTS

The safest way to work with pigments is to purchase ready-made paint. The next safest is dispersion. Some dispersions may contain a small amount of mineral spirits, but, says Art Guerra, who sells these pigments in his New York City shop, "If the wax has 20 percent pigment, and the pigment has 10 percent spirits, that's a tiny percentage of toxic materials." (You'll ventilate, of course, using a fan to draw fumes out of the studio.) Then there's powder. "If you use dry pigments, you need a system," says industrial hygienist Monona Rossol. She recommends a particle mask and a glove box with exhaust.

Safety hazard: There are hundreds of pigments, each with its own way of irritating or damaging the lungs, heart, kidneys, liver, or nervous system if inhaled or ingested over time. Particularly dangerous are cadmium, chromium, cobalt, lead, and mercury.

Resolution: Eliminate pigments containing lead and mercury. For the other toxic pigments noted, use dispersion or buy the paint ready-made. Use a glove box to isolate any powdered pigment until it is in the wax. When you paint, wear latex gloves (or vinyl if you are allergic to latex). Gloves keep pigment from irritating your skin or entering your blood via breaks in the skin.

Safety hazard: If you grind pigment with a muller and slab, you are at risk until the powder is safely in the wax. Spilled powder is also a hazard.

Resolution: Don't grind pigments alone; particles can become airborne. And don't use turpentine or wax paste to contain the powder; their solvents introduce a vapor hazard. Instead, use a few drops of linseed oil. If you spill pigment, wipe it up with a damp or oily paper towel. Do not vacuum it: "Most particles are small enough to go through the average vacuum cleaner and back into the environment," cautions Rossol.

Safety hazard: Prussian blue pigment, also known as *milori blue,* can contain low levels of residual cyanide gas, says paintmaker Art Guerra. "You are not protected even by a respirator's organic vapor cartridge."

Resolution: Ventilate! The fumes will disperse harmlessly into the outside atmosphere. Incidentally, cobalt and cadmium, which are made at temperatures as high as 2000°F, are quite stable in wax kept at normal encaustic temperatures, between 165°F and 220°F.

Safety hazard: Glass jars and plastic bags can break, spilling their powder.

Resolution: Upon purchase, ask that pigments be packaged in plastic tubs with secure lids. If you transfer pigments yourself, do so in a glove box. Dispose of the original containers by placing them into a plastic bag, and seal the bag before putting it in the trash.

Pigment Protection

When you are working with pigments, a disposable, bonded-fiber particle mask that fits securely over your nose and mouth is essential. A good example is the 3M #8210, available from hardware stores. Cost: about one dollar. "This mask is 95 percent effective on particles down to .3 microns," says a 3M spokesperson. "If you use cadmium or other heavy metals, we suggest the R-8233." Cost: about seven dollars. (Prices for both are lower if you buy in bulk.)

A disposable mask can be reused, says the spokesperson, "but make sure you store it in a way that the side facing you remains clean." How do you know when to toss it? "When breathing gets difficult." That's because the toxic particles are trapped in the filter fabric, close to your nose and mouth; therefore, you should not wait too long before replacing the mask. If you work with pigment infrequently, you can use the mask about six or eight times. But if you've had a marathon paintmaking session, toss the mask when you're finished. ●

A GLOVE BOX

Powder pigments are stored on a shelf inside Sara Mast's glove box, which is fitted with rubber gloves for handling materials and a Plexiglas top for viewing the process. In this shot from above, we see the artist mixing pigment into molten wax.

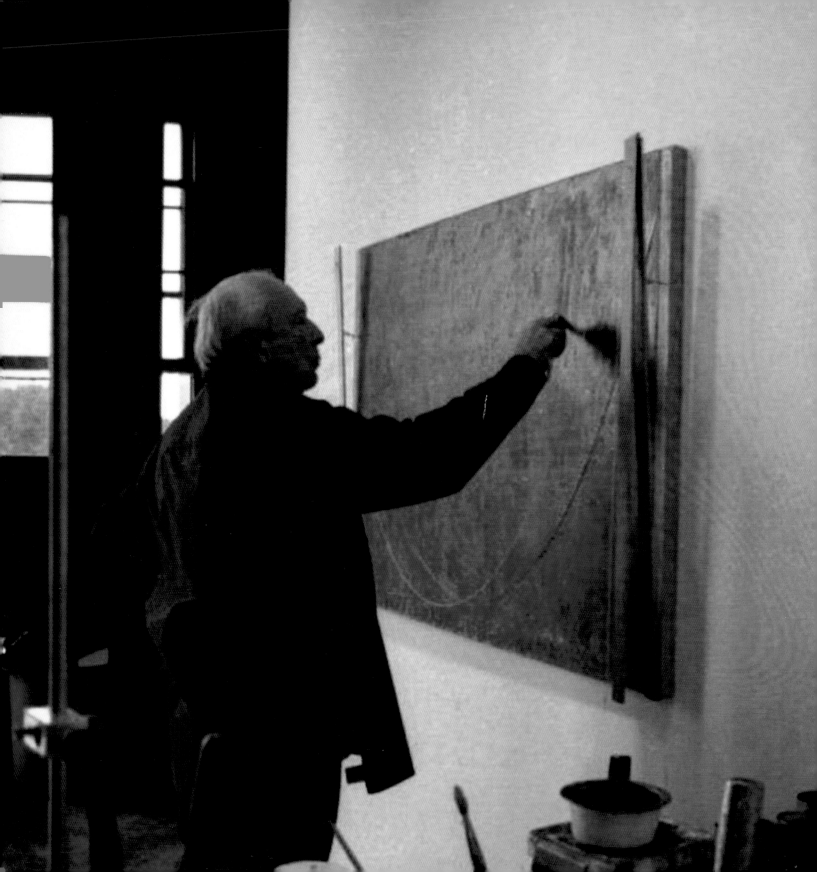

Painting: Preparation and Techniques

In our six-word encaustic formula—melt wax, add pigment, paint, fuse—we have considered every word but one: *paint*. Painting in encaustic is different from any other medium in that the molten wax paint begins to harden the moment it leaves its heat source. To fight this essential character is to be defeated. In encaustic you literally have to go with the flow. That means working quickly to place your stroke, even if you meditate for twenty minutes on precisely where to place it. Of course, encaustic is also extremely forgiving. Don't like what you've just put down? Scrape it off and try it again. I thought I was really onto something—digging, scraping, incising—until most of the artists I spoke with told me of their similar "discovery." It seems the subtractive aspect of working in encaustic is as much a part of the process as the additive.

The fact that encaustic can resist us with every dip of the brush, yet be so yielding as a surface, keeps us endlessly engaged. Yes, wax cooling and hardening in midstroke can be a bane and a challenge, but it's just the flip side of waiting for paint to dry.

We also need to read between the lines of our formula, for to paint, we need to *prepare to paint*. I was introduced to encaustic in a painting materials class in art school. Though I warmed immediately to the medium and process, I was frustrated by the traditional preparation—endless rounds of glue gesso—so much so that I didn't return to encaustic for twenty years. But what at the time was presented as the only way to properly prepare for encaustic is now just one of many viable options, all infinitely less demanding. No doubt this ecumenism is another part of encaustic's newfound appeal.

I have invited artists who are represented in this book to speak to their specialties of preparation and technique. As the following pages make clear, there are many ways to make a beautiful and archival encaustic painting. The important thing is that pigment, medium, ground, substrate, and support work together as one, to the extent that any group of discrete elements can.

OPPOSITE: **JASPER JOHNS AT WORK**
The artist at work in 1999 on a painting in his Connecticut studio. Note his uncomplicated system for melting wax, lower right: a saucepan on a hot plate.

Substrates and Grounds

Encaustic requires a rigid *substrate*. In Fayum portraits, the substrate is a thin panel of cypress, sycamore, or other hardwood; today a wood substrate is either a dense and rigid composition board, such as Masonite, or a laminate like plywood, created from thin layers of wood whose grain is laid at successive right angles to reduce warpage.

The substrate supports the *ground*, the surface on which you paint. The ground must adhere well to the substrate while accepting the paint with just the right degree of absorbency. *Gesso*, Italian for gypsum (chalk), has become the generic term for all grounds made with chalk, pigment, and binder, but acrylic gesso does not readily accept wax and so is not appropriate for encaustic. "I've seen a whole encaustic painting slide off an acrylic gesso ground," says veteran painter Rachel Friedberg.

WHAT ARTISTS ARE USING

Inventiveness and modern materials have combined to give us many choices for substrate and ground, as these artworks illustrate. You'll create a combination based on how you work. Are you a digger? You need a sturdy substrate like plywood. Are you a dauber? A soft ground, like hide-glue gesso or wax-coated paper, would be fine.

Unprimed Panel

Hot wax sinks right into unprimed wood, a tendency furthered by fusing.

Martin Kline uses the *lauan* ground as a visual element of his work (opposite), but it is also possible to cover the ground completely. (Lauan is a light, inexpensive one-quarter-inch mahogany plywood good for small or large work.)

Primed Panel

Forget glue gesso for the moment. It is far easier to prime with wax.

Rachel Friedberg applies beeswax medium with a soft, wide brush onto smooth, furniture-grade *birch plywood* and fuses it. In her painting (page 114), the wood is a compositional element. One-half-inch to three-quarter-inch plywood makes a sturdy, if heavy, substrate.

Sara Mast (pages 10, 83, and 121) fuses straight-from-the-apiary beeswax onto *exterior plywood*. The glue in this construction-grade laminate withstands moisture, so it's a good choice as long as the surface will be minimally visible under the paint.

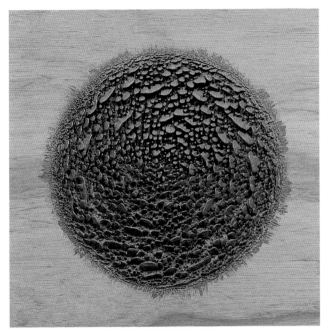

Martin Kline **GREEN EYE**
encaustic on lauan panel, 15 in. × 15 in. × 3 in., 1999

Wood accepts wax very well. Kline has applied wax directly to his panel. You can also prime a panel with clear or pigmented wax.

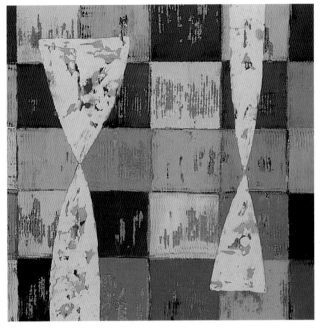

Chris Kelly **CAFÉ AU LIT**
encaustic on linen on birch plywood, 12 in. × 12 in., 1995–96

Kelly has scraped right to the quick, so his toothy linen canvas becomes an essential element of the surface.

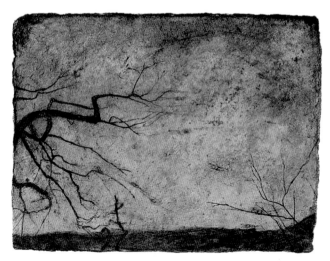

Leigh Palmer **BEFORE SPRING**
encaustic and mixed media on paper on board, 9³⁄₄ in. × 13 in., 1995

Watercolor paper makes a wonderful ground for encaustic if you prime it with one or two coats of wax, fusing after each application.

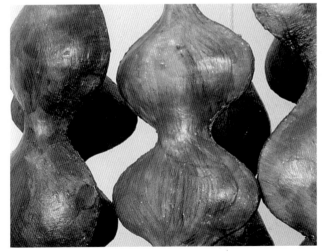

Sylvia Netzer **MIASMA MORPH**, detail (full view, page 74)
wax and pigment on fired ceramic, 1996

The practice of coloring wood, clay, and marble sculptures dates to antiquity. Here you see the wax's translucency and the artist's brushstrokes.

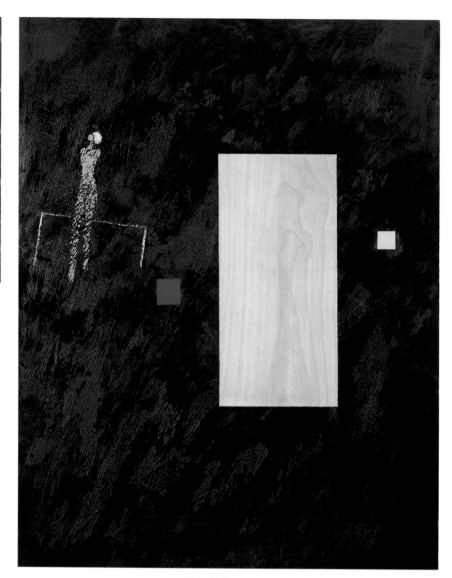

Joanne Mattera QWERTY #2 (front and back views)
encaustic on canvas on lauan panel, 12 in. × 12 in., 1999

*Though stretched canvas is not intrinsic to my substrate
(lauan) or ground (pigmented white beeswax), it creates a
protective middle ground as I scrape and gouge the surface.*

Rachel Friedberg MOLLY
encaustic on birch plywood, 30 in. × 24 in., 1992
Collection of Alexandra Komerak

*By using clear beeswax medium, Friedberg has visually integrated her
birch plywood substrate into the composition.*

Laura Moriarty (pages 52, 121, and 124) applies pigmented white wax to hollow-core lauan doors finished to size at the lumberyard. "Though I find these panels a bit bulky, they allow me to work large without getting heavy. And they don't torque," she remarks. (Hollow-core panels are sometimes referred to as *doorskin*.) Here's a tip: If you drill a few finger holes at the back, near the sides, the panel will be easier to grasp and handle. Use a small circular saw blade of the type that is normally used to cut doorknob holes; select the diameter just large enough to accommodate a finger grip.

Paper on Panel

You can create a simple ground by gluing *watercolor paper* onto panel (as Leigh Palmer, page 113, has done) and then waxing it. The panel can be any wood laminate. Other options include featherweight *hex panel*, a cardboard honeycomb sandwiched between two thin layers of plastic or aluminum, and the old standby, *Masonite*. (*Tempered* panel, harder and more warp-resistant than untempered, may not absorb wax well, but it is a fine substrate for wax-absorptive paper or canvas. Further, some new versions, tempered with resins rather than oil, may be more wax-friendly.)

Canvas on Panel

If you work the surface aggressively, canvas creates a layer between ground and substrate. I *stretch cotton canvas over braced lauan* (opposite), while Chris Kelly (page 113) *stretches linen over panel*.

Robin Rose (right) *glues linen onto the surface of hex panel*. The panel is vulnerable at the perimeter, he points out: "You have to fill in the edges or they will collapse." Rose uses Bondo, an automotive putty, for the fill-in.

Yet More Options

- If you work small and not too forcefully, *Clayboard* offers a ready-to-use kaolin ground on a flat or braced panel.

- Gessolike *joint compound*, used to seal drywall seams, is composed of chalk, clay, and polymer binders. Leigh Palmer trowels it onto a canvas-covered panel. "The ground is so absorbent, I size it with rabbit-skin glue to keep the first layers of wax from soaking in too far," he says.

- In painting wax onto her *fired clay* sculpture (pages 74 and 113), Sylvia Netzer brings us full circle to early encaustic, in which wax was used to polychrome vessels and statues.

Robin Rose EXTREMITY
encaustic on linen on honeycomb panel, 24 in. × 18 in., 2000

You can't see the lightness of this honeycomb panel, and that's the point. New materials improve a painting in myriad ways without changing the essence of the work.

SOME SUBSTRATE OPTIONS

From left: *hollow-core lauan door (also called* doorskin*); untempered Masonite (you'll find better quality at an art supply store, where product is designed for painting, than at the average lumberyard); furniture-grade birch plywood; lightweight mahogany lauan; and cradled Clayboard.*

A SELECTION OF TOOLS

For mitering: miter box, left, and chop saw. For joining: spring and C-clamps. Glues: PVA and Elmer's. For sanding: fine-grit paper wrapped around a block of wood. For larger constructions: a drill, bits, wood screws. You'll also need a metal ruler or measuring tape.

BRACED SUBSTRATES AND GROUNDS TO MAKE YOURSELF

You can buy braced substrates in many standard sizes or have special sizes custom built. But making your own is easy and inexpensive, especially if you work in a small format.

Notes on the Options Shown

Two ways to make a braced substrate are pictured *opposite*. The *panel-and-stretcher* option is fast, clean, and doesn't require carpentry tools. Keep dimensions under twenty-four inches and you will not even need glue.

You have many panel choices. The *braced-panel* option requires the tools shown (below left). Angled corners are strong and good-looking, but if you don't have a chop saw or miter box, make straight cuts with a handsaw. Cut long braces to run edge to edge on two parallel sides; fit shorter lengths into the space remaining at the opposite edges.

You have many easy ground options, too. You can glue paper or canvas to the substrate and wax it. Or wax a wood substrate directly with clear or white-pigmented wax.

With More Carpentry Experience . . .

If you're not up for the time and labor demand of constructing your own supports, read no further. Go paint. However, if you have the will and a chop saw, consider the suggestion of David Headley, owner of Downtown Stretcher Service in New York City, for a sturdy perimeter brace: "Buy a sheet of three-quarter-inch birch plywood and have the lumberyard rip it into one-and-three-quarter-inch strips. You'll have a stack of perfectly straight boards to make a cradle that looks as good as any frame." The boards should be angle-cut at the corners, glued, and clamped.

As your substrates increase in size, the technical demands will be greater. At thirty-six inches, you will need *corner braces*. Headley suggests you cut diagonal half squares to screw into the corners of the perimeter brace. "With a painting larger than three by four feet, a cross-brace every sixteen inches is imperative," he says. Typically, that means a lap-jointed grid, but you could stagger vertical supports off a central brace that runs edge to edge horizontally. Secure the supports with wood screws.

SUBSTRATE OPTION #1: PANEL AND STRETCHER

1. *You need: stretchers (here, twelve inches by twelve inches) and a same-size panel, canvas, canvas pliers, and a stapler. Assemble the stretcher. Align panel atop the assembled stretcher.*

2. *Work from the back. Stretch canvas over panel and frame, stapling from the center outward, as you would conventionally. Canvas holds the substrate in place.*

3. *The substrate keeps the canvas rigid. Edges are clean and smooth. This system works with all dimensions, but at more than twenty-four inches you may need to glue substrate to stretcher.*

SUBSTRATE OPTION #2: BRACED PANEL

1. *You need: panel (here, twelve-inch-by-twelve-inch lauan), mitered braces (here, cut twelve inches at longest end), PVA glue, and clamps. If you have a strong grip, spring clamps are fast and easy.*

2. *Squirt glue onto panel and braces. Set the first brace; clamp from center. Set the second brace at opposite side. Continue, making sure corners meet cleanly. You can fill small gaps with wood putty.*

3. *The finished support is clean and simple. Lightly sand the surface and edges. You can glue paper or fabric to the substrate, or apply a wax ground. All options are shown below.*

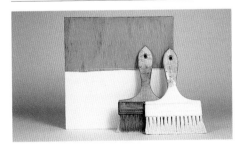

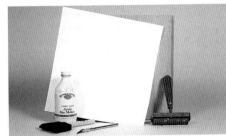

GROUND OPTION #1: WAXED PANEL

Apply clear wax to the wood panel. Melt it into the surface. Apply a second layer and fuse. Want a white ground? Add a layer of white-pigmented wax (I did so on half of the panel so you could see both options). Fuse. Your ground is ready.

GROUND OPTION #2: COVERED PANEL . . .

Glue watercolor paper, as here, or canvas with PVA glue or acrylic polymer (acrylic is okay because it doesn't come in contact with the wax). With a brayer, apply pressure from the center outward. Weight with a book for thirty minutes.

. . . WITH A WAXED GROUND

Once you've stretched canvas over a braced substrate, or you've glued paper or canvas to the substrate, brush on clear wax and fuse. Apply and fuse a second layer. As with Ground Option #1, additional layers of white wax are optional.

Recipe: Rabbit-skin Glue Size

YOU NEED:

- rabbit-skin glue (powder or granules dissolve faster than sheets)
- cold tap water
- double boiler (or a coffee can set into a pan of water)

PROCEDURE:

In the top of a double boiler, to each quart of water add two to three tablespoons of glue. Soak overnight, or until glue swells to a jellylike consistency. Put double boiler on medium heat. Stir constantly, making sure the mixture does not boil. The glue size is ready when the jelly melts, about fifteen minutes.

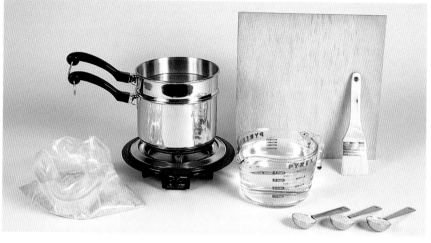

MAKING GLUE SIZE

A double boiler keeps the top-pot liquid under 212°F. This is essential, because glue properties will change if the mixture boils. From left: rabbit-skin glue crystals; the prepared glue size; the ingredients: two to three tablespoons of crystals to one quart of water; the panel, ready for sizing.

Sizing allows the panel to accept the gesso evenly. Coat both sides of the sanded panel with the glue size (coating the back of the panel is not essential if you are using a thick laminate or braced panel). Dry for four to six hours.

Recipe: Gesso

YOU NEED:

- whiting (artist's or gilder's quality)
- titanium or zinc pigment powder
- prepared glue size
- cheesecloth

PROCEDURE:

Mix nine parts whiting and one part pigment (a total of three pounds dry ingredients) in a large bowl or container. Slowly add mixture to one quart warm glue size (see recipe for rabbit-skin glue size, above). Heat in double boiler about fifteen minutes until creamy, stirring constantly. Do not let mixture boil. Strain and use warm.

MAKING AND APPLYING GESSO

Heat the chalk/pigment/glue size mixture for about fifteen minutes. Don't let it boil. "I wait until mine lets off a little steam," says artist Timothy McDowell. From left: The ingredients, nine parts whiting to one part titanium, to be mixed together and sifted into the glue size; the prepared gesso; a spoon for stirring; cheesecloth for straining the gesso; the gessoed panel.

Applying gesso: "Seven coats are traditional," says McDowell. Brush in one direction. Apply each new layer crosswise to the one before. Wait thirty minutes between coats. After twenty-four hours, McDowell applies a layer of clear, untempered beeswax to seal the gesso before he begins to paint.

TRADITIONAL HIDE-GLUE GESSO

Gesso made from hide glue and chalk is composed of three elements: the *filler*, calcium carbonate as whiting or precipitated chalk; the *binder*, hide glue (conventionally called rabbit-skin glue); and the *whitener*, zinc or titanium pigment powder.

There are many gesso recipes, each a delicate balance of ingredients affected by humidity, temperature, and quality of materials. For encaustic, you need a recipe that holds the wax. Timothy McDowell, who paints on a gesso ground, here shares his recipes and their subtleties.

Preparing and Using the Glue Size

Glue size is essentially watered-down glue. To ascertain whether you have a good mixture, "dip two fingers into the glue size and then wave them in the air. If your fingers stick together, the glue is strong enough," says McDowell. (It's more likely that your glue will be too strong than too weak, so be prepared to add a few drops of water.)

You'll use the glue size not only to bind the gesso, but also to prepare your wooden panel for the gesso. When the glue is ready, thinly brush it onto the sanded panel, front and back. "Let it dry fully, four to six hours, then sand the panel lightly with fine-grit sandpaper before you apply the gesso," recommends McDowell.

Preparing and Applying the Gesso

McDowell sifts his chalk/pigment mixture into the warm glue size. "I use a chopstick to stir. When I pull the stick out and it has a thin, opaque coating—like milk—that's when I quit adding the powder." Cook on low heat for about fifteen minutes. "All you're doing is giving the dry material a chance to absorb the liquid," he explains.

You'll apply three to seven layers, "so don't worry if the first layer appears thin," says McDowell. "When the first layer turns from glossy to dull white, apply the second layer. You can apply one coat every thirty minutes." Keep the gesso warm: "Each new layer must be warmer than the surface because the new layer has to activate the gelatin in the previous layer." A final sanding is optional. (Let the surface dry for six hours before sanding, and be sure to wear a mask.)

Timothy McDowell **BOUGH**
encaustic on birch plywood, 60 in. × 48 in., 2000

"Gesso was invented for panel painting. It has been used as a ground since the Middle Ages," says McDowell, who uses seven layers to prepare each panel. He may add pigment to his top layer to achieve a slight tint: "It doesn't have to be white."

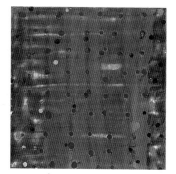

QWERTY 11, 1999
Collection of Sunjit Chawla

Wax is used thinly with the transparency of watercolor.

CERA 5, 1995
Collection of Judy and Paul Mattera

Many layers of clear wax create a translucent surface.

DÉJÀ VU 1, 2000

Pigment is dark, opaque. Layers are revealed by scraping.

TRANSPARENT. TRANSLUCENT. OPAQUE.
Just as there is a range of textures, there is a continuum of light permeability. Try both variables in different combinations. These encaustic works, all 12 in. × 12 in., are by the author.

The Encaustic Surface

The synchronicity of temperature and tool gives you full control over the medium.

TEMPERATURE

Heat is of the essence in encaustic; the more you can adjust it, the greater your control.

THE WAX: Beeswax with damar is safely workable from 160°F to 220°F. At the lower end of the temperature range, it goes on thick and creamy, a consistency good for scumbling and creating texture; at the higher end, it goes on almost syrupy, better for creating a smoother surface.

THE GROUND: Warm the ground from above or below and your surface will remain workable longer. From above, use bulbs, adjusting the temperature by watt, size of reflector, and distance between bulb and surface. From below, place the substrate on or above a warm palette (about 100°F) so that the ground is heated evenly.

THE FUSING TOOL: An iron, fusing by direct heat, creates a smooth surface. A small propane torch or air-and-temperature-adjustable heat gun, wielded from either a slight or greater distance, lets you run a textural range, from retaining the subtleties of the applied surface to melting it completely—even pushing it around.

TOOLS

You can extend and exploit the variations in temperature by the way you apply the wax.

THE BRUSH: A soft-hair brush lays down a smooth stroke, while firm bristles can leave a nicely textural trace in wax. Heather Hutchison often uses cheap foam brushes from the hardware store to make a clean edge-to-edge application. But, she notes, they'll melt in hot wax, "and they stink when they melt."

THE SPATULA: Any broad blade—palette knife, putty knife, Sheetrock taper—lets you spread the wax, from delicately buttering the wax to plastering it with tooth and heft.

THE IMPROVISATION: You can also daub, drip, and pour in large or small measure.

Sara Mast **INDIAN FLATS,** detail (full view, page 83)

The surface is worked with a variety of short and long strokes, both scumbled and wax laden. . .

Richard Frumess **THE SEDUCTION OF RIBYK,** detail (full view, page 36)

. . . to applying scumbled strokes that create a visual interaction of colors and layers . . .

Joanne Mattera **TOGETHER AGAIN,** detail (full view, page 137)

. . . to building up the surface, then scraping selectively to reveal a hint of the painting's history . . .

Laura Moriarty **DANGEROUS PASSAGE,** detail (full view, page 124)

. . . to "building down" an image by shaping it from layers of color that have been laid one over the other.

Miriam Karp SPIN
encaustic on panel, 63 in. × 36 in., 1997

Here the surface is built up to relief texture via stenciled objects and spattered paint.

The Surface: Textured

Creating texture is the easiest part of encaustic painting, not only because wax has physical density, but because it drags on the surface as it cools. The result is that each successive stroke builds up most heavily where the wax has dragged.

BRUSHSTROKES

The detail (page 121) of Sara Mast's *Indian Flats* shows three kinds of brush-strokes: In the blue area, she has worked a *short, light* stroke, scumbling it layer over layer. Scumbling does not totally obscure the previous layer, so visual texture is added to physical. In the same area, she has laid down a *longer, smoother* stroke with hotter wax to create the lattice. Over to the right, she has daubed a wax-laden brush onto the surface. Mast works vertically, so the daub readily runs, the effect of which is an impasto of *daubing and dripping.*

TEXTURAL ACCRETION

In *Spin* (left), Miriam Karp has juxtaposed two dramatic textures. For the delicate pattern at top, she laid lace onto the surface, painted over it, and then pulled it up, creating a textural imprint of the real thing. Below it, she built a filigree of spatters. You can also pour or drizzle the wax onto the surface with a batik tjunting or wax writer.

AFFECTING THE TEXTURE WITH HEAT

Light fusing maintains texture; heavy fusing—melting—extends drips and creates ripples or holes; selective melting redefines the terrain. Rachel Friedberg (pages 35 and 132) builds up the surface with a brush and then flattens it in places with an iron, helping to create a compelling landscape for her narrative imagery.

GETTING SCULPTURAL

Want to construct a surface? Use higher-melting microcrystalline wax as an underbody—brush it on, build it up, and carve into it. Beeswax painted onto it can be fused without the microcrystalline giving in to the heat. Deep relief will need an armature: Before painting, insert or attach metal or wooden rods into or onto the substrate, or create a contoured substrate. Expect large works to be heavy and relatively fragile.

The Surface: Smooth

If a textured surface is the easiest to achieve, a smooth surface is the hardest. In your attempts, you can try various methods.

POURING IT ON

Two artists who achieve extreme smoothness pour their wax. I must note, however, that neither works in true encaustic: Tom Sime (who describes his technique on page 94) uses paraffin over oil; Eric Blum uses beeswax interspersed between layers of oil or over resin. Pouring onto a true encaustic painting is harder because the hot wax tends to pit the existing surface. Still, it is worth considering Sime's and Blum's techniques, if only to adapt them.

Blum, a master of the beeswax surface, heats his wax in a saucepan to 250°F. Working quickly back and forth, he applies the wax in one pour, letting it drip over the sides. He then uses a small propane torch to fuse the layer and refine the surface. In adapting his method for true encaustic, I added more damar to the penultimate layer (one to five instead of the normal one to eight) so that it wouldn't melt so readily under a barely 200°F pour. The results hold promise and are worth exploring, at least on a small scale.

HEATING THE SURFACE

If you work in a small format and have a lot of patience, set a painting under a 100–200 watt lightbulb. You must monitor the process carefully: just as the top layer begins to melt, move the lamp away—fast. Repeat as necessary, using the lamp to deliver more or less heat as needed. You can combine this technique with the next.

SCRAPING AND HEATING

I usually employ a combination of scraping and melting, though I prefer a heat gun or an iron to a bulb. With a small work, it is easy to lay down a top layer of wax with a soft, wide brush. When the wax is cool enough, I smooth it by scraping and then heat it again. Repeating this process several times yields a smooth, but not pristine, surface. Larger works require a greater degree of effort, and some overlap of brushstrokes may remain. I may further smooth the surface with Bestine solvent on a soft cloth. Though this is the least toxic of the solvents, I keep my exhaust fan on high.

BUFFING

When the surface is hard, buff lightly with a clean, soft cotton cloth.

Eric Blum **N. 349**
oil and beeswax on birch plywood, 15 in. × 15 in., 1997

This surface was attained by pouring, melting (using a propane torch), and buffing.

Joanne Mattera **ALBA**
encaustic and oil stick on canvas on braced lauan,
10 in. × 10 in., 1994

This surface was attained by brushing, melting (with a heat gun and Bestine solvent, used separately), scraping, and buffing.

The Surface: Scraped

Because wax yields its surface so readily, both scraping and incising are integral to the repertoire of many artists. These techniques are often used complementarily.

Andrew Nash **NOTES #3**
wax and mixed media on canvas on board, 36 in. × 28 in., 1999

"I arrive at imagery that comes from the repeated action of building up and tearing down the wax surface," says Andrew Nash. "What I love about the medium is that the more it's worked upon—in my case, gouged into and scraped down—the richer and more interesting the surface becomes."

THE WAX

A beeswax ground tempered with a higher-than-usual degree of damar, carnauba, or candelilla should withstand your incursions. With that same degree of temper in the painting layers, the wax will flake and crack as you scrape it, while a standard or less-than-standard temper will curl off in soft ribbons. There is no right or wrong recipe here, only what works for the effect you want to achieve. Note, though, that warm wax is quite malleable, perhaps too much so, and tends to gum up the tools.

THE TOOLS

There are no official implements or techniques. I like clay trimmers of the sort used to shape still-wet pots; I drag them along the hardened surface—lightly to skim an onionskin layer of wax, heavily to gouge the surface. You might also try palette knives, kitchen utensils ("pie cutters," suggests Sara Mast), or razor blades. If a tool looks promising, try it; what doesn't work for one surface may be ideal for another.

Orlando Leyba reaches the underlying layers of his work with chisels, planers, and sandpaper—archaeological forays abetted by the desert sun, which this New Mexico native often enlists to soften or melt the surface while he works.

Chris Kelly, a self-described "tool junkie," prefers blades, including cabinet scrapers and wallpaper smoothers. These implements not only cover a large area, but they do so evenly. However, he notes, "Even wax dulls the edge," so sharpen often. (You'll find files and sharpening stones at hardware stores and in tool catalogs.)

SCRAPING TO REVEAL WHAT IS UNDERNEATH

Scraping is negative painting, a "building down" to create the image. In *Dangerous Passage* (left), Laura Moriarty went through many layers and colors to achieve her image. Given wax's acquiescence, it is possible to remove too much. One way to maintain an area you like is to glaze it with medium. That way, even as you continue to work the surface you will have protected what you have created.

Laura Moriarty **DANGEROUS PASSAGE**
encaustic on braced lauan, 40 in. × 48 in., 1999

The artist selectively scraped through layers of paint to develop her image.

The Surface: Incised

Incising is related to writing in its most archetypal form—a scratch in soft soil, a mark in wet clay—and to printmaking, as in the carving of a woodblock or the engraving of a plate; so it is not surprising that many incised works have a strong graphic sensibility. Sabina Ott and Louise Weinberg have incised letters and words, respectively, while Ron Ehrlich and Tracy Spadafora have created pictographs with the suggestion of narrative.

THE WAX

The same tips noted for scraping are useful here. However, scribing into soft wax (still warm or mildly tempered) lets you exploit both line and material.

THE TOOLS

Anything with a point is useful, and implements from many disciplines are eminently adaptable: fine-pointed dental picks, printmakers' tools (a great resource), leatherworking awls, or kitchen equipment. Wood-carving tools can make fine gouges, while wood-burning tools let you scribe by melting. Anything goes.

THE TECHNIQUES

Using the tool of your choice, you can incise shallowly or deeply.

- **INTAGLIO,** employed in printmaking, is the incising of a surface. The displaced wax creates a ridge of exploitable texture. If you don't like that ridge, slice it off with a palette knife. You can borrow from printmaking and "ink" the incised lines, wiping off the excess that remains on the surface—although you'll use oil stick or oil paint rather than ink. The wet pigment will bleed into subsequent layers of wax, a result you can manipulate to wonderful effect with heat. If you'd prefer to keep your lines clean and solid, encapsulate them with a localized dab of clear medium; fuse, and keep working.

- **SGRAFITTO,** employed in plaster or clay work, is the incising of a surface to reveal the color of an underlying layer. (You do this on a more complex scale when you scrape.)

- **INTARSIA** is a woodworking technique in which small pieces of wood are laid into a scribed or channeled surface. In encaustic, you fill in the channel with molten wax. Brush it into the line, let it harden, then scrape away the excess on the surface. Voila! A clean, perfectly controlled line or mark.

A SELECTION OF SCRAPERS AND SCRIBERS
This is what you'll find in my studio: palette knives, clay trimmers, putty knives, and some pointed tools. Your studio may have an entirely different selection. Use whatever works.

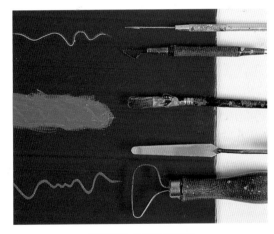

INTARSIA, STEP BY STEP
This sample board shows you how I did it and the tools I used, but there is plenty of room to develop this technique.
Top: Scribe a line with a pointed implement.
Middle: Generously apply molten paint to the incised line. You don't have to be neat.
Bottom: When the wax is hard, scrape it back. Your finished line is clean and precise.

ABOVE (DETAIL) AND TOP (FULL FIEW): **Tracy Spadafora MEMORY**
mixed-media encaustic on Masonite, 16 in. × 32 in., 1997

Spadafora used collage on both panels of this diptych, most noticeably on the left, where she wax-glued photocopies of one of her own photographs and then applied layers of pigmented and unpigmented wax medium. (On the right panel, she scribed the surface and applied oil stick into the lines.)

Louise Weinberg HOPE/LOSS
encaustic and collage on rag matboard on Masonite,
6 in. × 12 in., 1999

In this mixed-media work, the artist scribed the soft wax surface and then filled it in with pigment. (The pictorial imagery was achieved via collage.)

Collage and Mixed Media

As we know from the hive, wax has the ability to encapsulate. That makes it an ideal medium for collage and mixed-media work. Early on, Jasper Johns collaged newspaper into his targets, while Michelle Stuart embedded flower petals into her earth-focused works.

I have not tried encaustic collage, and my mixed-media experience is confined to a collaborative series in paint, wax, thread, and pins with the painter Patrick Weisel, so I have enlisted the two artists whose encaustic work is shown on these pages: Cynthia Winika has taught workshops at Yale University, the San Francisco Art Institute, and in Italy; she teaches regularly at R&F Handmade Paints in Kingston, New York. Tracy Spadafora has taught and demonstrated privately and at museums and colleges all over New England.

COLLAGE

Just as with conventional collage, you advance the work element by element. The difference here is that you use beeswax as the glue—and you can glue anything that is absorbent.

Substrate and Ground

You need a rigid surface, ideally reinforced with bracing. A waxed or papered substrate makes a fine ground. Or, says Spadafora, begin the collage conventionally and separately, then glue it to an unwaxed substrate before you start layering with the wax.

The Techniques

The following five techniques can be freely developed:

- **LAYERING:** If you're working a flat collage with paper, photographs, or fabric, you don't have to apply a lot of wax, says Spadafora: "The surface looks much thicker than it is because of the optical depth." If you're working in relief, Winika suggests you develop height incrementally: "Build up the surface with lots of thin layers." Fuse well.

- **EMBEDDING:** Objects should be small enough to encase between the layers, suggests Winika. Place an object on the surface, encapsulate it with a brushstroke, and fuse. Wax seals out air but not ultraviolet light, so leaves and other organic material may yellow over time.

- **TRANSFERRING IMAGES:** Black-and-white photocopies are easily transferred to wax, says Spadafora: "Start with a cheap toner photocopy. Flip it over onto cool wax, burnish it, and peel up the paper. If you want more of the image to release, wet the face-down paper with a sponge to dissolve the bond between toner and paper." Unless you use solvents, ink-jet and laser prints don't release their color well. Still, Winika has found that Hewlett Packard ink-jet prints—"fresh copies"—are quite manipulable.

- **GILDING:** Perhaps inspired by Fayum portraits, many artists are trying gold leaf. Says Winika, "It's best to use gold leaf as a top layer, where it's most reflective. The tack of wax holds it on." She burnishes with a cotton ball and fuses with radiant heat, finding the gun too forceful. You can layer wax over the gold, but you'll lose the brilliance. However, Winika notes, scraping—into the wax to expose the gilding, or into the gilding to expose the under layer—produces beautiful effects of its own.

 In creating *Pacific on Pacific* (right), Winika layered a waxed photocopy onto a cadmium red ground. "The translucency of the waxed paper let me see the red glowing through," she says. Then she laid gold leaf, burnishing it lightly in one direction with a cotton ball and fusing it to the wax with the heat from a low-wattage lightbulb. Winika has found that contemporary resin-coated photographs need to be sanded lightly to give them the tooth they need to accept the wax; here, she sanded the photo and then encapsulated it with a brushstroke of wax.

- **ADDING ON:** You can model or cast objects in wax and fuse them to the surface. Working simultaneously, you'll heat both the area that will receive the object *and* the base of the object. Then set the object onto the surface, where both molten layers will fuse as one. (Tip: Melt the base of the object on a hot palette.) You can further fuse with a hot palette knife or other tool. How high can you go? While that depends on the size and the weight of the work, typically the limit is two or three inches without an armature.

MIXED MEDIA

Assemblage is the dimensional "cousin" to collage, while mixed media is the anything-goes-in-any-dimension relation. However you work, keep archival basics in mind: Use a rigid but absorbent surface. Fuse well. Spadafora advises, "Don't use acrylic paint; it won't form a good bond with the wax." Think about support and stability. Experiment, but know that the more elements you have in one work, the greater their stress on the work, as they react to external conditions in their individual, perhaps conflicting, ways.

Cynthia Winika **PACIFIC ON PACIFIC**
encaustic, gold leaf, photograph, and Xerox print on braced lauan,
10 in. × 10 in., 1999

This painting contains layers of photo images and gilding over a pigmented wax surface.

Cynthia Winika **TORN MONEY PAPER/OCEAN BY SPIRAL**
encaustic, collage, and Xerox transfer on braced lauan,
10 in. × 10 in., 1999

On watercolor paper glued to lauan, Winika painted a thin layer of cobalt green oil paint and then embedded pieces of Chinese money paper into layers of wax. On the opaque top half, she transferred a photocopy of her own drawing.

Encaustic on Paper

Paula Roland **STRATA III**
encaustic monotype on paper, 30 in. × 22 in., 2000

Roland's unique prints, pulled from wax applied to a warm palette, are often mounted onto heavier paper. Though she says results are "fairly unpredictable," she exercises control by manipulating the wax as she works, adjusting heat and pigment density.

RIGHT: Don Maynard **PRIMITIVE GEOMETRY**
encaustic on paper, 25 in. × 38 in., 1999

Using conventional drawing materials along with plain or pigmented beeswax, the artist builds up the surface and selectively scrapes back, thereby exploiting the sculptural quality of the surface.

Beeswax on a flexible surface would seem an oxymoron, for encaustic painting requires a rigid substrate. However, thinly waxed paper is extremely pliable. To increase pliability, skip the hardening agent. Instead, plasticize beeswax with a malleable microcrystalline, or use the microcrystalline on its own.

Wax sinks into the paper, becoming one with the surface. Japanese rice papers and lightweight drawing sheets will turn translucent where they are touched by the wax. Watercolor and thick handmade papers won't become translucent unless they are impregnated, either by immersion or by heat.

SOME TECHNIQUES

Keep heat under 220°F, and aim for flexibility via thin layers of wax.

- **DRAWING:** Don Maynard (below) exploits the "sculptural elements of the paper," here a 110-pound watercolor sheet. He employs drawing materials and mark-making, along with brushed-on encaustic, to build the surface, which he then selectively scrapes back with a razor blade. Maynard's drawings are large for encaustic—this one is twenty-five by thirty-eight inches.

- **PRINTMAKING:** My experience has been with smaller work. The print you see on the opposite page is from a series of *wax-on-vellum monoprints,* "pulled" from the surface of molten wax. Working within the area of an electric fryer (opposite, bottom), I touched one half and then the second half of a small sheet to the surface of the wax.

Overprinting tends to melt the first layer, so you need to work with lower temperatures for successive layers. You can create a larger surface by using a shallow baking pan on a griddle.

Paula Roland (opposite) makes *monotypes*, or what she calls "encaustic offset prints." On an aluminum surface heated from below with four 100-watt bulbs, she draws with sticks of wax paint, keeping the surface just warm enough to melt the wax. She transfers the image to paper by laying a sheet on the plate and rubbing the back with a brayer or wood block. "The wax soaks in. Then I pull it up," Roland says. Most prints are made by a single pass, but, she notes, "With varied pigments, paper, and temperatures, you can create a range of effects."

- **PAINTING:** Melissa Meyer's looping skeins of color (pages 7, 88, and 89), the result of a collaboration with master printer Garner Tullis, have the transparency of watercolor with the density and brilliance of encaustic. "By thinning the pigment with paint thinner and adjusting the temperature of the heat table, I was able to obtain the fluidity, luminosity, and look of rapid execution that I am attracted to," she says. Meyer discovered another bonus: "The surface remains workable. If I wanted, I could take a piece back to the heat table and loosen it up a little."

MOUNTING THE WORK

Waxed paper is hard to mount. It doesn't adhere well to conventional surfaces, and if it is translucent, most attachments will be visible from the front. Some ideas:

- **MASK OFF A ONE-INCH TOP STRIP,** front and back, to resist the wax. Later, remove the tape and fold the strip, using it as a mountable hinge. (Translucent work will need a liner.)

- **MASK THE BACK:** If you're working on heavy paper that will not become translucent, Cynthia Winika suggests you mask off a couple of squares at the back: "When you remove the tape, you'll have a clean surface for mounting." To adapt this idea for completed work, take a rectangle of heavy paper, and score and fold it in half. Wax one half and fuse it to the back of the work (watch the heat); use the clean half as your hinge.

- **AFTER THE FACT:** I have mounted translucent works with straight pins in the top corners. For opaque work, Don Maynard suggests hot glue: "I scrape the back of the paper, add the glue, and press it to the new surface." The safety of this method, he notes, depends on the thickness of the paper and the heat of the glue.

Joanne Mattera **DEPARTURE #11**
encaustic on vellum, 9 in. × 9 in., 1999

I was intrigued by the cell-like patterns that form on the surface of molten wax when titanium white is mixed with other colors. Vellum complements the translucency of the thin layer of wax.

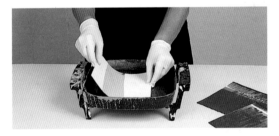

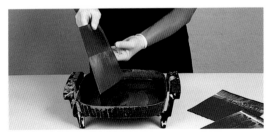

MAKING A MONOPRINT

An electric fryer offers a hot surface for making small monoprints. In the upper view, I touch one half of a small watercolor sheet to the wax surface. In the lower view, I've just done the same to the second half and am holding up the pulled print. (Wondering where the cord is? I unplugged it just before carrying the fryer over to be photographed.)

Thinking Big

Working big means thinking big. Consider:

- **SAFETY:** Where is your exhaust fan? Is your ladder sturdy? How are your neck and wrist? Wielding a heavy heat gun across a large area for long periods can impinge nerves and strain muscles.
- **FRAGILITY:** Installing a large work in an exhibition is a one-time deal, but galleries are constantly pulling out work to show clients. Big work is stressed at corners and edges, which means it can crack or chip.
- **WEIGHT:** Lauan and hex panel are lighter than fiberboard or plywood. This difference in weight is important. When a painting holds ten or twenty pounds of wax, it's hard to move and expensive to ship.
- **SHIPPING:** Although weight factors in here, size is the primary issue. Are your carpentry skills sufficient to construct a truck or air-freight crate that anchors the work within the container? If not, you'll need to have your crates made, and that's costly. ●

TIMOTHY MCDOWELL IN THE STUDIO
McDowell's cleated hanging system, one used by many museums, lets him employ the wall as his easel. Two bars on the wall give him the option of working higher or lower.

Large-Scale Encaustic Painting

If you're challenged by encaustic at eighteen by twenty-four inches, consider the logistics of working three or four times that size—or larger. Everything increases: the amount of wax, the fusing time, the weight of the painting, the space you need to store it, and the price you pay to ship it. And, of course, there are the physical stresses on both you and the painting.

HOW ONE ARTIST DOES IT

Sara Mast works vertically on paintings that range from a "small" of thirty-two by forty-eight inches to a large of eight by twenty feet (see the installation *Indian Flats*, page 83).

"Working as large as I do is physically demanding," she says. "It requires moving quickly before the molten wax hardens, going up and down a ladder as I paint, and then descending to step back to see the whole image. On my ladder I've attached a warming tray to keep cans of paint molten. I use both hands, fusing with a heat gun as I paint.

"The paintings are made up of plywood panels, each thirty-two by forty-eight inches. On the back of each panel I glue one-by-twos around the edges and across the middle to control warpage. I attach the panels with a brace in back. I paint the surface as a full piece but break it down into individual panels (or groups) for shipping, slicing the wax with a razor at the joints if necessary. Each back brace is fitted with a collar screwed to the packing crate; that way the panel can be suspended and nothing touches the surface of the painting."

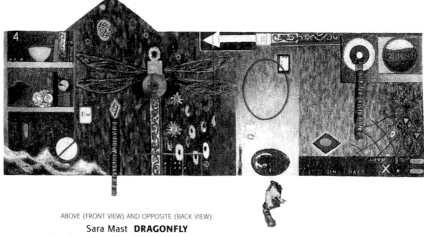

ABOVE (FRONT VIEW) AND OPPOSITE (BACK VIEW):
Sara Mast DRAGONFLY
encaustic and mixed media on plywood, 54 in. × 96 in., 1998
Collection of James and Wendy Morgan

INCREASING YOUR OWN SCALE

Mast's description is instructive because she touches on the following elements:

- **PAINTING VERTICALLY:** Working at an easel or on the wall frees you from the discomfort of bending over or straddling an expansive horizontal surface. The vertical orientation also lets you view the work as it is ultimately meant to be viewed. Jasper Johns (page 110) and Timothy McDowell (opposite) also work this way.

 McDowell, who paints on three-quarter-inch plywood, hangs his panels with a simple museum mount. Horizontally across the back of each panel, he attaches a one-by-four-inch wood brace cut with a downward angle along the bottom edge. It fits into a corresponding brace anchored to the studio wall. The system can hold several works, and each work can be easily moved. What's more, says McDowell, "The brace keeps the panel from warping."

- **WORKING MODULARLY:** By creating a painting in component parts, you eliminate much of what is difficult about large-scale work: making, storing, shipping, and hanging it. The components can be bolted together or hung discretely. For instance, Barbara Ellmann's installations are created from smaller constituents independently installed (right, top), while many of Michelle Stuart's large paintings are in reality a grid of wax-painted paper sheets attached by Velcro to a stretched canvas. My diptychs and triptychs are not bolted, but the panels, hung from carefully measured D-rings, meet cleanly to form a unified surface (right, bottom). I employ modularity this way to eliminate physical stress to myself and the painting.

Barbara Ellmann NINE PATHS
encaustic on paper on birch ply panels; each panel: 16 in. × 16 in.;
overall dimensions: 64 in. × 64 in., 1998

Ellmann's installation grid repeats and amplifies the formal composition of the individual components, each based on the mandala-like Parcheesi board.

Joanne Mattera ACCANTO À TE
encaustic on canvas on panel; two panels: one 48 in. × 32 in.,
the other 48 in. × 16 in., 1999

This diptych is not bolted, but the panels were constructed and prepared for hanging so that they meet and look as one.

Mast works with thirty-two-by-forty-eight-inch plywood modules. This becomes clear when a peek behind the painting reveals that two individually cross-braced panels are joined around the outer edges of the work. The cross-braces are glued, while the perimeter bracing and central vertical support are attached with wood screws—all the better for disassembling this heavy painting for safe shipping or storage.

Preparing and Exhibiting Your Work

With an increasing number of artists working in wax, we're seeing more encaustic-based art on exhibition. In turn, ever more collectors, drawn to its brilliant color and luscious surfaces, are acquiring encaustic work for personal and corporate collections.

Gail Stavitsky, who curated *Waxing Poetic: Encaustic Art in America* at the Montclair Art Museum (see Contemporary Encaustic, page 21), says her show "was the result of ten years of looking." The show's focus on encaustic was a testament not only to the medium's growing presence in the galleries but to how it is regarded. "What strikes me is the sheer beauty, physicality, and metaphorical richness of encaustic," says Dr. Stavitsky. "Its great strength is its versatility."

And its weakness? "The potential for damage if works aren't properly packed or handled." That potential was magnified in the minds of other curators, she says. "One of the main problems in not being able to travel the show more extensively [it did go to the Knoxville Museum of Art in Tennessee] was the unwarranted fear about the work melting." Still, artists did not always prepare their work for shipping as well as they should have. As an example, Stavitsky cites one painting that arrived protected by only a sheet of cardboard on its surface. This chapter will help you think about exhibiting your work and suggest ways to prepare it so that it will remain as you have made it, even when you are unable to look after it yourself.

A final thought about fragility, real and perceived: Encaustic's archival issues are different from those of conventional painting, but they are not more severe. You can prove this to encaustic's critics—or doubting curators—by using appropriate substrates and grounds (no acrylic gesso!), tempering your wax within reasonable parameters, and keeping your heat under 220°F to maintain wax integrity. If you're an experimenter, Cynthia Winika offers this advice: "Learn the best, most archival ways of working. When you know what you're doing, *then* you can break the rules."

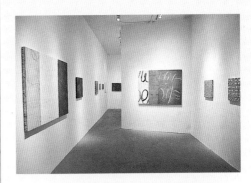

ONE EXHIBITION OPTION: NO FRAMES
In this 1999 show at the Marcia Wood Gallery, in Atlanta, I opted to present my work unframed. I see the drips as a visible record of the history of each piece, although I have scraped off enough wax to keep the edges from breaking. Not all dealers or collectors are enamored of this approach. Hope Turner of Boston's Arden Gallery is one: "For me, the drips are like underwear showing."

OPPOSITE: Rachel Friedberg **SHARDS OF GLASS**
encaustic on birch plywood, 72 in. × 72 in., 1997

Protecting Your Work

The moment you send your art outside the studio, you cannot control what happens to it. You can, however, practice a kind of "remote control" by preparing it well.

PROTECT EDGES AND SURFACES

As painters, we may obsess about the surface, but dealers and conservators are equally concerned about the edges—in particular, the overhang that develops as layers of wax flow over the surface and down the sides. Often the overhang breaks off, taking a chunk of the surface with it. "I do see that happen," says Michael Duffy, associate conservator in the paintings department at the Museum of Modern Art in New York City.

As much as I love that lip on my own work, I have learned to scrape it back as I'm working so that the edge of the surface is flush with the support. A good deal of the visual history of the painting remains in the form of lesser drips, but the overhanging lip goes. If you can't live without that lip, consider a protective frame.

Should you frame? "A frame is essential for protection," says Duffy, taking the conservator's position. For museum professionals, an "L" frame, such as the one protecting Jasper Johns's *Fall* (page 23) is a good, if costly, place to start.

A dealer sees it differently: "A contemporary painting doesn't necessarily call for a frame, especially as it gets larger and its borders dissolve in space," says New York City gallery owner Stephen Haller. Atlanta dealer Marcia Wood agrees: "The way artists treat space and the edges, you wouldn't want to frame the work."

From a collector's point of view, the issue is different yet again. "We have clients who live in pristine houses. They want pristine edges," says Hope Turner, owner of the Arden Gallery in Boston. "We usually frame a token piece from a show so that clients can see what their own paintings might look like framed."

Let me take the artist's point of view: If I don't frame, I am suggesting that this is how I see my work on the wall. On the other hand, if I frame simply, I not only protect the work, I help insure that the painting won't end up with a visually intrusive cornice in its new home. If you choose to frame, consider a minimal strip frame that safely encloses the edges, rising just high enough above or beyond the surface to protect it as well. This is the solution Barbara Ellmann chooses for her paintings (opposite).

CREATE A PROTECTIVE BOX FOR EACH PAINTING

Whether or not you frame, you need a box to house your painting for storage or transit. I have designed a cushioned slipcase (see sidebar, opposite) that protects the surface and edges. Perhaps you have a different system. "The important thing," says Haller, "is that you have something for the painting to go into when it comes off the wall."

TRANSPORT YOUR WORK SAFELY

Within a range of about 35°F to 120°F, wax can travel safely without cracking or melting. Your best bet is via an insured art handler. If you ship by land, look for a company with a climate-controlled van and—this is essential—experience with encaustic work. Use packing materials that protect and insulate. Before work leaves my Manhattan studio, I place each painting into its cushioned box and wrap it with a double layer of bubble wrap.

If you ship by air freight, you'll need to make or buy a crate. Despite your time and expense in procuring a crate, your art will be treated like any other cargo unless your shipper can expedite it quickly onto or off the plane. Specialized shipping is not cheap, but it is infinitely less costly than a haul-anything company that leaves you with melted or cracked work.

I have sent small works by FedEx's next-day service, packing a bubble-wrapped box securely within a larger box, but the insurance limit on artwork (five hundred dollars), requires backup studio insurance. Other carriers may offer more coverage at an extra charge. Ask for an early-evening pickup to minimize the time the work spends in transit.

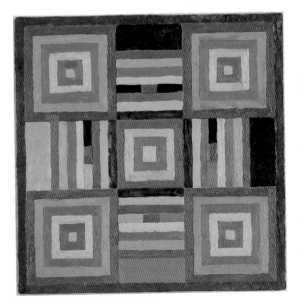

Barbara Ellmann
ROYAL TOUCH, detail
16 in. × 16 in.
(full view, page 77)

Here's an edging option: a strip frame. Ellmann, who works modularly with paper-laminated wood panels, uses a thin strip frame that surrounds each panel while unobtrusively remaining in the background. "Since I like the irregular waxed edge to show, the frame is recessed," she says. The painting is still protected because the frame extends out from the work.

What the Conservator Sees

Michael Duffy, associate conservator in the paintings department at New York's Museum of Modern Art, works on all kinds of paintings, including encaustic.

What problems have you found with encaustic?
Encaustic paintings have a durable overall integrity, but the surface is susceptible to scratching. The issue comes up again and again. From a conservation point of view, those scratches cannot be totally gotten rid of without intervention by the artist.

Do you mean applying heat?
Correct. Jasper Johns has done that. But conservators are conservative. Heat is taboo. We worry about moving the wax around, even if it's at the edge.

How do you treat the surface then?
Minor scratches are best left alone unless they diminish the visual field. For gouges we use a water-based fill material, coloring it with watercolor or dry pigment to match the encaustic surface.

An artist would fuse a broken edge back on. How do you deal with it?
We'd use a compatible—and reversible—adhesive, such as a water-based polymer, to put it back on. Then we'd protect the edge. That may be as simple as adjusting a frame so that it extends up a bit higher to protect the edges and the surface.

Are there other archival problems?
If the support is flexible, you can see cracks where the canvas goes over the stretcher. Or you can have blistering where air pockets rise to the surface. You have artists who use too much pigment or not enough medium. Sometimes you see rivulets of resin, which indicate the medium was not entirely mixed before application. With aged works, you might have cracks due to temperature extremes. ●

What the Dealer Expects

"I'm interested in the integrity of the work physically as well as conceptually. I have come to not want to work with art that is overly fragile or not protected properly, no matter how wonderful it is," says Marcia Wood, owner of the Atlanta gallery that bears her name. "It does neither me nor the artist any good to be constantly repairing work."

TALK TO THE DEALER ABOUT YOUR WORK

Wood suggests you start with full disclosure. "If you're new to encaustic or you have used a mix of media that might behave in unexpected ways, be up front with the dealer," she says. "I depend on what artists tell me about the work and where its fragility lies so that I can determine the best way to handle it—because the same issues that an artist has with fragile work, the dealer and the client have with it, too."

Stephen Haller likes the dialogue for another reason. "The artists can tell me about their technique and materials, so that when a client has questions about the work, I have a good and responsible response."

If you're the first encaustic artist to show in a gallery, prepare some information for the dealer. "People are drawn to the luminosity and the surface of encaustic, but they want to know the work will hold up," says Hope Turner. She offers visitors a fact sheet.

When you are unsure who will be handling your work—such as at a regional or juried show—put a note on the front of your custom-made box, something like, "Please keep painting away from heat and direct sun. Place it in this slipcase when it is not on display."

EXHIBITING? HAVE AN EMERGENCY REPAIR PLAN

If you are sending an exhibition's worth of work to a gallery, it is not unrealistic to assume that *something* can go wrong. Ideally, it will be a ding that can be repaired with a palette knife and the heat from a cigarette lighter. But if the corner of a painting has broken off—or worse, disappeared—what do you do? For large paintings, the ones most likely to sustain damage, I keep a "chip file" (opposite, bottom) and take it with me, along with a heat gun, a few palette knives, and some bristle brushes, when I go to inspect a show before the opening.

When I finish a large painting, such as *Together Again* (opposite, top), I put good-size pieces of leftover paint into a Ziploc plastic bag—a few colors per bag—along with a Polaroid photo of the painting. That way, if the work is

damaged in transit or during installation, I have the material to effect a repair. I don't take this precaution with small works, as a drip or two usually provides enough touch-up material to fix any damage.

I have found that dealers and collectors appreciate the extra effort. As Marcia Wood points out, no one wants to make repairs a regular part of the encaustic process, but it is worth having a worst-case-scenario plan. Down the road, I hope I will make some museum conservator very happy.

Joanne Mattera TOGETHER AGAIN
encaustic on canvas on panel, triptych: 48 in. × 70 in., 1998

A SIMPLE SYSTEM FOR REPAIR

This is my "chip file" for Together Again (top). I store wax remnants in a plastic bag, along with a Polaroid of the painting they belong to. Even years later, I will have the exact material to touch up or reconstruct a section of painting, if circumstances warrant.

Collectors Ask: "Will It Melt?"

"That's the question everyone asks," says Atlanta dealer Marcia Wood. "I assure collectors that it would take extreme heat to harm a painting, and that they wouldn't want to put *any* fine art in direct sunlight, whether it would melt or not."

Wendy Haas, owner of the Cervini Haas Gallery in Scottsdale, Arizona, makes an important distinction between *direct sunlight* and *daylight*. Haas's air-conditioned gallery has two large exhibition walls facing east onto the street. She has installed my paintings there, and when collectors see that no harm comes to the work, their fears about melting wax are allayed. Haas is careful, however, to remind her clients about heat. She recounts this story that made the rounds in her town: "A collector bought two encaustic paintings, put them in the trunk of her car, and went shopping. It can get up to 120 degrees here, so you can imagine the temperature inside the trunk. She returned to puddles of wax where the paintings had been."

Surprisingly, extreme cold can be almost as bad. "The brittleness of a paint film is vulnerable to cracking," says MOMA's Michael Duffy, noting, "Heat is part of the encaustic process in a way that cold is not." Case in point: One upstate New York artist left a wax-on-panel painting in his car on a sub-zero winter night. "By the next morning, the painting had separated from its ground," he reports.

Still, melting wax is a collector's biggest fear, so we give painter Tom Sime the last word on ambient temperature: "I tell collectors, 'Wax melts at 150 degrees. If my paintings are melting in your house, you've got a bigger problem. Your house is on fire!'" ●

Sources

Following are resources recommended by the artists represented in this book; most have catalogs or on-line services, and all ship around the country.

ART BOARDS
612 Degraw Street
Brooklyn, NY 11217
(718) 237-0109
www.art-boards.com
Artist-run business; maple plywood and untempered fiberboard, cradled and as flat panels. Of note: panels slotted for hanging; many sizes available.

DILCO REFINING CO.
John Dilsizian
73-35 Grand Avenue
Maspeth, NY 11378
(718) 458-0400
Waxes of all types, plus damar, in this second-generation refinery. Of note: custom blending and knowledgeable service; minimum order is sixty pounds.

DOWNTOWN STRETCHER SERVICE
David Headley
50 Washington Street
Room 525
Brooklyn, NY 11201
(718) 222-2909
www.stretchers.com
Artist-run business; custom-made stretchers and cradled panels, including lightweight solutions for large-scale work.

ENKAUSTIKOS
3 North Washington Street
Rochester, NY 14614
(800) 536-2830
www.fineartstore.com
Wax paint, wax, pigment powder, damar, brushes, tools; also, innovative tools developed by artist Ann Huffman for making fine lines: a wax pen with inter-changeable nibs, and a hot brush with interchangeable brass brushes. Of note: paint available by the pound; on-line catalog.

GAMBLIN PAINTS
(503) 235-1945
www.gamblincolors.com
Artist-run business; check Web site for stores that sell their oil paint, pigment powder, and beeswax pastilles. Of note: good safety info and Gamblin Color Book available on Web site.

GUERRA PAINT AND PIGMENT
510 E. 13th Street
New York, NY 10009
(212) 529-0628
Artist-run business; dispersion and powder pigments, beeswax. Of note: knowledgeable service over the phone.

KREMER PIGMENTS
228 Elizabeth Street
New York, NY 10012
(212) 219-2394
www.kremer-pigmente.com
Pigments, wax, damar, hide glue, gesso supplies; on-line catalog. Of note: E-mail hotline for your pigment questions.

LEE VALLEY TOOLS
P.O. Box 1780
Ogdensburg, NY 13669
(800) 871-8158
Woodworking tools, some of which can be adapted to encaustic uses.

MASTERPAK
(800) 922-5522
www.masterpak.com

Archival-quality glassine, silicone release paper, Tyvek, packing supplies of all kinds.

NEW YORK CENTRAL ART SUPPLY
62 Third Avenue
New York, NY 10003
(800) 950-6111
www.nycentralart.com
Wax, pigments, R&F encaustic paint, gesso supplies, substrates. Of note: an extraordinarily helpful sales staff; if you can't visit the store, request a catalog.

PEARL PAINT
308 Canal Street
New York, NY 10013
(800) 451-7327
www.pearlpaint.com
Wax paint, waxes, pigment powder, damar, brushes, gesso supplies from twenty retail stores around the country and mail order sources.

PERMACOLORS
226 E. Tremont
Charlotte, NC 28203
(800) 365-2656
www.permacolors.com
Pigments, mullers and slabs, hide glue, chalk, brushes. Of note: three-eighths-inch plywood panels primed with glue gesso or laminated with linen.

R&F HANDMADE PAINTS
506 Broadway
Kingston, NY 12401
(800) 206-8088
www.rfpaints.com
Artist-run business; the best commercially made wax paints available, in a range of sixty-six colors; encaustic medium,

oil-paint sticks, tools, workshops; gallery, including biennial juried exhibition; print and on-line catalog. Of note: Web site full of technical and historical information, newsletters. Call 800 number with any questions about encaustic.

REED WAX
167 Pleasant Street
Reading, MA 01867
(800) 336-5877
Waxes of all types; custom blending.

FRANK B. ROSS CO.
22 Halladay Street
P.O. Box 4085
Jersey City, NJ 07304
(201) 433-4512
Waxes of all types, including custom blending. Of note: minimum order ten pounds; prices better on orders over one hundred pounds.

SINOPIA
3385 22nd Street
San Francisco, CA 94110
(415) 824-3180
www.sinopia.com
Wax paint, pigments, wax, damar; on-line catalog. Of note: "Encaustic Forum" invites on-line information exchange.

DANIEL SMITH
4150 First Avenue South
P.O. Box 84268
Seattle, WA 98123
(800) 426-6740
www.danielsmith.com
Pigments, waxes, brushes, gesso supplies, tools; illustrated print catalog.

Galleries and Museums

The galleries listed here regularly exhibit the encaustic work of artists shown in this book. The museums listed include Fayum portraits in their collections. Not all galleries feature encaustic painting in every exhibit, and not all museums have extensive collections of Fayum portraits. Before you make a special trip to view work, check to confirm operating hours and that the work you want to see is on display.

Space and clerical limitations prevent me from listing museums in whose collections the artists of this book are represented, but I would be remiss if I did not note that the work of Jasper Johns is in many museum collections here and abroad.

GALLERIES

ANDOVER, MASSACHUSETTS
Alpers Fine Art (Tracy Spadafora)

ATLANTA, GEORGIA
Marcia Wood Gallery (Miriam Karp, Joanne Mattera, Tony Scherman, Bill Zima)

BOSTON, MASSACHUSETTS
Arden Gallery (Ron Ehrlich, Joanne Mattera)

CHICAGO, ILLINOIS
Art Mecca Gallery (Joanne Mattera, Tremain Smith)
Perimeter Gallery (Bill Zima)

DALLAS, TEXAS
Mulcahy Modern Gallery (Tom Sime)

DENVER, COLORADO
William Havu Gallery (Lawrence Argent)

KANSAS CITY, MISSOURI
Morgan Gallery (Sara Mast)

LOS ANGELES, CALIFORNIA
Fred Hoffman Galleries (Tony Scherman)

MINNEAPOLIS, MINNESOTA
Flanders Contemporary Art (Sara Mast)

NEW YORK, NEW YORK
A.I.R. Gallery (Sylvia Netzer)
Denise Bibro Fine Art (Tom Sime)
Bridgewater/Lustberg & Blumenfeld Gallery (Gail Gregg, Leigh Palmer)
Leo Castelli Gallery (Jasper Johns)
Donahue/Sosinski Art (Nancy Azara)
Stephen Haller Gallery (Elaine Anthony, Ron Ehrlich, Johannes Girardoni)
Elizabeth Harris Gallery (Elisa D'Arrigo)
June Kelly Gallery (Kay WalkingStick)
Lennon, Weinberg Gallery (Mia Westerlund Roosen)
Marlborough Gallery (Martin Kline)
Howard Scott Gallery (Robin Rose)
Sears-Peyton Works on Paper (Don Maynard)
John Weber Gallery (Michelle Stuart)
Winston Wächter Mayer Fine Art (Tony Scherman)

NEW YORK STATE
Carrie Haddad Gallery, Hudson (Pamela Blum, Leigh Palmer)
Lorraine Kessler Gallery, Poughkeepsie (Pamela Blum)
Oxford Gallery, Rochester (Pamela Blum)
R&F Gallery, Kingston (monthly shows of encaustic art)

PHILADELPHIA, PENNSYLVANIA
Rodger LaPelle Galleries (Benjamin Long)
Rosenfeld Gallery (Tremain Smith)

PORTLAND, OREGON
Augen Gallery (Chris Kelly)

SAN FRANCISCO, CALIFORNIA
Dolby Chadwick Gallery (Mari Marks Fleming)
Hespe Gallery (Bill Zima)

SANTA FE, NEW MEXICO
LewAllen Contemporary (Kay WalkingStick)
Peyton Wright Gallery (Orlando Leyba)

SANTA MONICA, CALIFORNIA
Ruth Bachofner Gallery (Lawrence Argent)

SCOTTSDALE, ARIZONA
Cervini Haas Gallery (Joanne Mattera)
Lisa Sette Gallery (Timothy McDowell)

SEATTLE, WASHINGTON
Winston Wächter Fine Art (Tony Scherman)

WASHINGTON, D.C.
Hemphill Fine Arts (Tim McDowell)
Marsha Mateyka Gallery (Sabina Ott)
Numark Gallery (Robin Rose)

INTERNATIONAL
Bau-Xi Gallery, Toronto (Don Maynard)
Espace Gallery/Christine Adapon Fine Art, Manila, Philippines (Joanne Mattera)
Galería Tomas March, Valencia, Spain (Bill Zima)
Galerie Barbara Farber, Amsterdam (Tony Scherman)
Galerie Daniel Templon, Paris (Tony Scherman)
Galerie Haas & Fuchs, Berlin (Tony Scherman)
Galerie Nanky de Vreeze, Amsterdam (Johannes Girardoni)
Galleria Marcello Rumma, Rome (Peter Flaccus)
Sable-Castelli Gallery, Toronto (Tony Scherman)

MUSEUMS

Brooklyn Museum of Art, Brooklyn, New York
The Cleveland Museum of Art, Cleveland, Ohio
The Detroit Institute of Arts, Detroit, Michigan
The J. Paul Getty Museum, Los Angeles, California
The Metropolitan Museum of Art, New York, New York
Philadelphia Museum of Art, Philadelphia, Pennsylvania
The Arthur M. Sackler Museum, Harvard University, Cambridge, Massachusetts

INTERNATIONAL
Antikensammlung, Berlin
The British Museum, London
The Egyptian Museum, Cairo
The Louvre, Paris

Glossary

ALLA PRIMA Italian for "at the first." It refers to a work created by the initial application of paint, with little or no overpainting.

BEESWAX wax from the honeybee, characterized by a sweet fragrance, soft translucency, low melting point, and significant malleability. For these reasons, as well as historical precedent, it is the preferred wax for encaustic.

BLEACHED BEESWAX beeswax that has been whitened by phosphoric acid, potassium permanganate, and hydrogen peroxide. Impurities have not been removed, but they have been decolorized.

BLOOM a film of whitish dust that appears on the surface of an encaustic painting as the result of a chemical reaction within the wax. A second type of bloom, crystalline formations within the wax, occurs when untempered beeswax has been exposed to below-freezing cold.

BRACE the term for a perimeter support attached to the back of a substrate panel to keep it from warping. Frame makers use the term *cradle*.

BURNING IN an essential element of the encaustic process, in which each newly applied layer of wax paint must be lightly melted to the one beneath it. Also called *fusing*.

CANDELILLA hard, plant-based wax that can be used in small amounts (ideally no more than 5 percent) to impart durability to beeswax for encaustic painting.

CARBON PIGMENTS pigments based on twentieth-century chemical technology. As opposed to mineral pigments, these colors do not occur in nature. *See* mineral pigments, pigments.

CARNAUBA the hardest of all the plant waxes; can be used in small amounts (ideally no more than 5 percent) to impart durability to beeswax for encaustic painting.

CRADLE the term for a perimeter support attached to the back of a substrate panel to keep it from warping. Artists often interchangeably use the term *brace*.

DAMAR the hardened sap of a fir tree native to the East Indies. This resin is used to make encaustic medium, typically one part damar to eight or nine parts wax.

DISPERSION PIGMENT a creamy, viscous substance composed of a large number of pigment particles held in suspension by a small amount of oil (usually linseed). The advantage of dispersion pigments over ground pigments is that there is no pigment dust to contaminate the studio.

EMULSION a suspension of one liquid within a second, usually by means of a third. Beeswax is emulsified in water by ammonia. The resulting paste, mixed with pigment, does not need to be melted or fused, so it is not true encaustic.

ENCAUSTIC from the ancient Greek *enkaustikos*, which means "to heat" or "to burn." Encaustic is the name for both a medium, pigmented wax, and the process, involving heat, by which the medium is applied and secured.

ENCAUSTIC MEDIUM a *medium* is the vehicle in which pigment is carried. With relation to encaustic, the term refers to beeswax in which a small amount of damar resin has been added for strength. The usual ratio is one part damar to eight or nine parts wax.

FAYUM PORTRAITS head-and-shoulder encaustic portraits, dating from Greco-Roman Egypt (100 B.C.–A.D. 200), that were set into traditionally wrapped mummy casings. Many of these portraits, now in museums around the world, remain in excellent condition even after two thousand years. *Fayum* is the name of the Nile oasis near which many burial sites were found.

FLASH POINT the high temperature at which wax combusts. To prevent this dangerous condition from occurring, encaustic painters are encouraged to maintain working temperatures not much higher than the melting point of wax.

FUSING an essential element of the encaustic process, in which each newly applied layer of wax paint must be melted to the one beneath it. Also called *burning in*.

GESSO Italian for "gypsum," i.e., chalk. Although gesso is now the generic term for all grounds made with chalk, pigment, and binder, only traditional gesso—made from calcium carbonate, hide glue, and zinc or titanium—is appropriate for encaustic.

GLUE SIZE a watered-down version of hide glue. In encaustic it has two uses: in gesso, to bind the calcium carbonate filler to the pigment; and in substrate preparation, to prime the surface of the wood panel that will accept the gesso.

GROUND the surface on which an artist paints. For encaustic this might be traditional gesso, waxed canvas or paper on panel, waxed panel, or even unprimed wood panel. The ground must adhere well to the substrate while accepting paint with the right degree of absorbency.

HIDE GLUE also known as *rabbit-skin glue*. It is a gelatinous adhesive made from the cooking of animal skin and water. (The edible version of this glue is gelatin.)

HYDROCARBON a compound containing only hydrogen and carbon molecules. Petroleum waxes are composed entirely of these molecules, while plant and animal waxes contain them in smaller measure.

INTAGLIO a printmaking term used to describe the incising of a surface. Wax easily lends itself to this technique.

INTARSIA a woodworking term used to describe the inlay of wood into an incised or channeled surface. In encaustic, wax is used for both the channel and the inlay.

LUMINOSITY the distinguishing feature of paintings made with transparent or translucent layers of wax. As light passes through those layers and is reflected up to the surface, the painting is actually illuminated from within.

MEDIUM the vehicle in which a pigment is carried.

MELTING POINT the temperature at which wax melts. Different waxes have different melting points.

MICROCRYSTALLINE a petroleum-based wax, introduced in the early twentieth century, composed entirely of hydrocarbons. It is produced by refineries in consistencies from soft and tacky to hard and brittle. Its promise for encaustic is that painters can select consistencies appropriate for their needs.

MINERAL PIGMENTS any pigment with metal as a base, such as natural iron oxide, synthetic iron oxide, or synthetic mineral pigments like cobalt, cadmium, and manganese. *See* pigment.

PARAFFIN an inexpensive, brittle, petroleum-based wax whose primary application in encaustic is as a brush cleaner.

PIGMENT an inert, finely powdered crystalline coloring material that does not dissolve into a medium but remains suspended within it.

POLLEN yellowish powder produced by plants for fertilization. Pollen is what gives wax and honey their golden tone.

PRIME to prepare the surface for painting so that a ground or first layer of paint will be accepted evenly and with the right degree of absorption.

PROPOLIS a resinous substance produced by honeybees to strengthen the hive or its components; bee glue.

PVA GLUE a fast-drying adhesive made from polyvinylacetate. It is used to adhere a wooden brace to the back of a wooden substrate, or to adhere paper or canvas to the face of the substrate.

RABBIT-SKIN GLUE also known as *hide glue*. It is a gelatinous adhesive made from the cooking of animal skin and water. (The edible version of this glue is gelatin.)

REFINED BEESWAX beeswax that has been cleaned of pollen, propolis, and other impurities by mechanical filtering.

RESIN a compound with strong film-forming properties. In encaustic it is used to increase the durability and hardness of beeswax. The primary resin for encaustic is damar.

SCUMBLE a thin layer of paint that does not completely cover the surface.

SGRAFITTO term from plaster or clay work that describes the scraping or incising of a surface to reveal the color of an underlying layer. Wax lends itself easily to this process.

SOLVENT a liquid used to dissolve or dilute wax, paint, and oily materials. Volatile solvents, such as turpentine or odorless mineral spirits, evaporate at room temperature. Most are harmful and therefore must be used with active ventilation.

SUBSTRATE the underlying layer on which a ground is applied. In encaustic, the substrate should be rigid so that the wax painting experiences a minimum of vibration during its lifetime. Substrates for encaustic include wood laminates such as plywood and lauan; pressed wood such as Masonite; and hollow-core surfaces such as lauan doors and thin aluminum panels supported by a cardboard "honeycomb."

TACK the quality of stickiness. In encaustic painting it refers to the ability of wax to adhere to itself or another substance.

TEMPER one substance added to modify the properties of another. In encaustic, wax is tempered by the slight addition of a hardening agent such as damar resin, or a softening agent such as linseed oil.

WAX a natural material from animal, vegetable, and mineral sources composed of acids, alcohols, esters, and hydrocarbons whose characteristics include luminosity, resistance to moisture, and extreme plasticity in the presence of heat.

Bibliography

GENERAL REFERENCES

Doerner, Max. *The Materials of the Artist and Their Uses in Painting.* Rev. ed. New York: Harcourt, Brace, 1984.

Gettens, Rutherford J., and George L. Stout. *Painting Materials: A Short Encyclopedia.* New York: Dover Publications, 1966.

Gottsegen, Mark David. *The Painter's Handbook.* New York: Watson-Guptill Publications, 1993.

Kay, Reed. *The Painter's Companion, A Basic Guide to Studio Materials and Methods.* Cambridge, Mass.: Webb Books, 1982.

Mayer, Ralph. *The Artist's Handbook of Materials and Techniques.* 5th ed. New York: Viking Penguin, 1985.

——. *Art Terms and Techniques.* New York: HarperCollins, 1966.

Smith, Ray. *The Artist's Handbook.* New York: Knopf, 1987.

Turner, Jane, ed. *Dictionary of Art.* New York: Grove's Dictionaries, 1996.

SPECIFIC REFERENCES

Feller, Robert L., ed. *Artists' Pigments: A Handbook of Their History and Characteristics.* Washington: National Gallery of Art, 1984.

Gamblin, Robert, and Martha Bergman-Gamblin. *Gamblin Color Book.* N.p.: Gamblin Artists Colors, 1996.

Huffman, Ann. *Enkaustikos! Wax Art.* Rochester, 1996.

Snyder, Jill. *Caring for Your Art.* New York: Allworth Press, 1996.

Turner, Jacques. *Brushes: A Handbook for Artists and Artisans.* New York: Design Press, 1992.

SAFETY

McCann, Michael. *Health Hazards Manual for Artists.* Rev. ed. New York: Lyons Press, 1994.

Rossol, Monona. *The Artist's Complete Health and Safety Guide.* 2nd ed. New York: Allworth Press, 1994.

HISTORY, ANCIENT AND CONTEMPORARY

Aubert, Marie-France, and Roberta Cortopassi. *Portraits de l'Egypte Romaine.* Paris: Réunion des Musées Nationaux, 1998.

Doxiadis, Euphrosyne. *The Mysterious Fayum Portraits: Faces from Ancient Egypt.* New York: Harry N. Abrams, 1995.

Stavitsky, Gail. *Waxing Poetic: Encaustic Art in America.* Montclair, N.J.: Montclair Art Museum, 1999.

Walker, Susan, ed. *Ancient Faces: Mummy Portraits from Roman Egypt.* New York: Metropolitan Museum of Art/Routledge, 2000.

Photo Credits

4: Red Elf Photography, courtesy of Sabina Ott. **5:** Bart Kasten, courtesy of Miriam Karp. **6 (TOP):** Giorgio Benni, courtesy of Peter Flaccus. **6 (BOTTOM):** Photograph by Robert Puglisi. **7:** Garner Tullis, courtesy of Melissa Meyer. **8:** Kevin Noble, courtesy of Martin Kline. **9:** Maja Kihlstedt, courtesy of Cynthia Winika. **10 (TOP):** Courtesy of Benjamin Long. **10 (BOTTOM):** Sara Mast and Terry Karson, courtesy of Sara Mast. **11 (LEFT):** Courtesy of Heather Hutchison. **11 (RIGHT):** Kim Harrington, courtesy of Mari Marks Fleming. **12, 13:** Jan Blair, courtesy of Nancy Macko. **24 (TOP):** Courtesy of the Stephen Haller Gallery, New York. **24 (BOTTOM):** Courtesy of Michelle Stuart. **26:** Courtesy of Signe Mayfield, Palo Alto Art Center. **27:** Courtesy of Dr. Gail Stavitsky, Montclair Art Museum. **28:** John Howarth, courtesy of Tony Scherman. **30:** Amanda Crandall. **31:** Andy Wainwright, courtesy of Leigh Palmer. **32, 33:** Timothy McDowell. **34:** John Howarth, courtesy of Tony Scherman. **35 (LEFT):** Stan Lichens, courtesy of World House Gallery. **35 (RIGHT):** Jeff Schnorr, courtesy of World House Gallery. **36:** Nancy Donskoj, courtesy of Richard Frumess. **37:** Maja Kihlstedt, courtesy of Cynthia Winika. **38:** Tracy Spadafora. **39:** Courtesy of the Stephen Haller Gallery, New York. **41:** Rick Antony, courtesy of Chris Kelly. **42:** Kim Harrington, courtesy of Mari Marks Fleming. **43:** Courtesy Rosenberg & Kaufman Fine Art, New York. **44:** Courtesy of Don Maynard. **45:** Courtesy of Nina B. Marshall. **46:** Robert Herman, courtesy of Lynda Ray. **47:** Courtesy of Lawrence Argent. **48:** Ray Robbennolt, courtesy of Karen J. Revis. **49:** David Wharton, courtesy of Tom Sime. **50:** Bart Kasten, courtesy of the Marcia Wood Gallery, Atlanta. **51:** Adam Reich. **52:** John Lenz, courtesy of Laura Moriarty. **54, 55:** Courtesy of Eric Blum. **56:** Courtesy of Benjamin Long. **57:** Joseph Painter, courtesy of Tremain Smith. **58:** Courtesy of Stephanie Brody Lederman. **59:** Bronlyn Jones, courtesy of Orlando Leyba. **60:** Courtesy of Olivia Koopalethes. **61:** Red Elf Photography, courtesy of Sabina Ott. **63:** Kevin Noble, courtesy of Martin Kline. **64:** James Prinz, courtesy of Perimeter Gallery, Chicago. **65:** Chan Chao, courtesy of Howard Scott Gallery, New York. **66, 67:** Bart Kasten, courtesy of Miriam Karp. **68:** Robert Puglisi, courtesy of Lorry Newhouse. **69:** Giorgio Benni, courtesy of Peter Flaccus. **70:** Pamela Blum. **71:** Kevin Noble, courtesy of Martin Kline. **72:** Courtesy of Lennon, Weinberg Gallery, New York. **73:** Christopher Burke/Quesada/Burke, courtesy of Nancy Azara. **74:** David Lubarsky, courtesy of Sylvia Netzer. **75:** Gene Kraig. **77:** Peter Chin, courtesy of Barbara Ellmann. **78, 79:** Peter Muscato, courtesy of Heather Hutchison. **80:** Courtesy of Gail Gregg. **81:** Andrew Gillis/Cascadilla Photo, courtesy of Kay WalkingStick. **82:** Jean Vong, courtesy of the Stephen Haller Gallery, New York. **83:** David Van Allen, courtesy of Sara Mast and Terry Karson. **84:** Courtesy of the Elizabeth Harris Gallery, New York. **85:** Courtesy of Michelle Stuart. **86:** Robert Puglisi. **88, 89:** Garner Tullis, courtesy of Melissa Meyer. **90 (TOP):** Scott Camazine. **94:** Courtesy of Tom Sime. **96:** Andrew Gillis/Cascadilla Photo, courtesy of Kay WalkingStick. **97:** John Howarth, courtesy of Tony Scherman. **98:** Joanne Mattera. **107 (TOP LEFT, TOP CENTER):** Joanne Mattera. **107 (TOP RIGHT):** Timothy McDowell. **109:** Terry Karson, courtesy of Sara Mast. **110:** Librado Romero/NYT Pictures. **113 (TOP LEFT):** Kevin Noble, courtesy of Martin Kline. **113 (TOP RIGHT):** Rick Antony, courtesy of Chris Kelly. **113 (BOTTOM LEFT):** Andy Wainwright, courtesy of Leigh Palmer. **113 (BOTTOM RIGHT):** Dorothy Handelman, courtesy of Sylvia Netzer. **114 (TOP LEFT):** Robert Puglisi. **114 (BOTTOM LEFT):** Ernest Oliveri. **114 (RIGHT):** Jeff Schnorr, courtesy of World House Gallery. **115:** Brendan Webster, courtesy of Robin Rose. **119:** Timothy McDowell, courtesy of the Lisa Sette Gallery, Scottsdale. **120 (TOP):** Robert Puglisi. **120 (CENTER):** Adam Reich. **120 (BOTTOM):** Robert Puglisi. **122:** Bart Kasten, courtesy of Miriam Karp. **123 (TOP):** Courtesy of Eric Blum. **123 (BOTTOM):** Adam Reich. **124 (TOP):** Courtesy of Andrew Nash. **124 (BOTTOM):** John Lenz, courtesy of Laura Moriarty. **126 (TOP AND CENTER):** Courtesy of Tracy Spadafora. **126 (BOTTOM):** Arnold Kanarvogel, courtesy of Louise Weinberg. **127:** Maja Kihlstedt, courtesy of Cynthia Winika. **128 (TOP):** Courtesy of Paula Roland. **128 (BOTTOM):** Courtesy of Don Maynard. **129 (TOP):** Robert Puglisi. **130 (LEFT):** Courtesy of Timothy McDowell. **130 (RIGHT), 131 (LEFT):** Courtesy of Sara Mast. **131 (TOP RIGHT):** Peter Chin, courtesy of Barbara Ellmann. **131 (BOTTOM RIGHT):** Robert Puglisi. **132:** Jeff Schnorr, courtesy of E. Peterson Editions, New York. **133:** Bart Kasten. **135:** Peter Chin, courtesy of Barbara Ellmann. **137 (TOP):** Robert Puglisi. **90 (BOTTOM), 95, 99, 101, 103, 104, 105, 107 (BOTTOM), 112, 116, 117, 118, 125, 129 (CENTER AND BOTTOM), 134, 136, 137 (BOTTOM):** Ernest Oliveri Studio.

Acknowledgments

I owe an enormous debt to the many artists who shared their thoughts about encaustic and allowed me to reproduce images of their work: Lawrence Argent, Nancy Azara, Amanda Crandall, Elisa D'Arrigo, Barbara Ellmann, Ron Ehrlich, Peter Flaccus, Mari Marks Fleming, Richard Frumess, Johannes Girardoni, Cheryl Goldsleger, Gail Gregg, Chris Kelly, Olivia Koopalethes, Gene Kraig, Stephanie Brody Lederman, Orlando Leyba, Benjamin Long, Nancy Macko, Nina B. Marshall, Don Maynard, Melissa Meyer, Laura Moriarty, Andrew Nash, Sylvia Netzer, Lorry Newhouse, Sabina Ott, Lynda Ray, Karen J. Revis, Mia Westerlund Roosen, Tremain Smith, Louise Weinberg, and Bill Zima.

I particularly wish to acknowledge those artists who opened their studios to me, either in person or via extended telephone interviews: Eric Blum, Pamela Blum, Rachel Friedberg, Heather Hutchison, Miriam Karp, Martin Kline, Timothy McDowell, Leigh Palmer, Paula Roland, Robin Rose, Tony Scherman, Tom Sime, Tracy Spadafora, Michelle Stuart,

Kay WalkingStick, and Cynthia Winika. Sara Mast and Terry Karson were most accommodating to my requests for detail photographs and ever more information. Jasper Johns was extremely kind to recount his experience with encaustic. In addition, I value the artistic collaboration that Patrick Weisel and I have pursued on the all-too-infrequent occasions when time and scheduling allow.

My sincerest appreciation goes to experts in other areas of art and industry who shared with me information on the life of bees, the intricacies of wax refining and paintmaking, studio safety, responsible archival practices, conservatorial practices, curatorial thinking—and who, in many instances, read sections of the manuscript. *Tante grazie*, Scott Camazine, John S. Dilsizian, Michael Duffy, Robert Gamblin, Art Guerra, David Headley, Ann Huffman, Dr. Jacqueline Moline, Monona Rossol, Andrew L. Smith, and Carolyn J. Tomkiewicz.

I would also like to acknowledge and thank the galleries and institutions that helped me secure images: Stephen Haller Gallery,

Elizabeth Harris Gallery, Howard Scott Gallery, Lennon, Weinberg Gallery, and Rosenberg & Kaufman Fine Art; the Brooklyn Museum of Art, the Nancy Graves Foundation, the Metropolitan Museum of Art, the Museum of Modern Art, and VAGA (particularly Heidi Coleman), all New York City; the Hirshhorn Museum, Washington, D.C. (particularly Amy Densford); Perimeter Gallery, Chicago; the J. Paul Getty Museum, Los Angeles (particularly Jacklyn Burns); the Palo Alto Arts Center (particularly Signe Mayfield); Bau Xi Gallery, Toronto; and Jasper Johns Studio (especially Sarah Taggart).

A thank-you goes to those who lent materials for photography: Dilco Refining, Enkaustikos Wax Art Supplies, and R&F Handmade Paints, as well as to photographer Ernest Oliveri, who took most of the process shots and still lifes.

I extend my deep gratitude to Stephen Haller and Daniel Ferris, the Stephen Haller Gallery, New York City; Marcia Wood, the Marcia Wood Gallery, Atlanta; Hope Turner and Zola Springer, Arden Gallery, Boston; Wendy

Haas, the Cervini Haas Gallery, Scottsdale; and Christine Adapon, Espace Gallery, Manila, for addressing the subject of dealers' concerns about encaustic (and for their much appreciated ongoing support). Dr. Gail Stavitsky, of the Montclair Art Museum in Montclair, New Jersey, addressed the curator's perspective. Let me single out Richard Frumess, artist and paintmaker, whose generosity of information embraced not only wax, pigment, and process, but extended to numerous referrals as well as his vast file of artists' slides.

Dr. Jerry Cullum wrote a splendid opening essay. Candace Raney, senior acquisitions editor at Watson-Guptill, recognized the need for a book on encaustic painting and was helpful throughout. With appreciation I note that Gabrielle Pecarsky edited the material with understanding and finesse. Finally, I offer a personal acknowledgment to Gloria DeSole and Meredith Butler, two wonderful friends who have maintained a decades-long interest in my work: Your support is water, air, and food for the creative soul. Thank you.

Index

Page numbers in italic refer to illustrations